HAYES & HARLINGTON

THROUGH TIME

Philip Sherwood

AMBERLEY

Acknowledgements

The photographs included in the book come partly from my own private collection and partly from material given to me over time. In the latter case I have acknowledged the source at the end of the relevant caption. Special mention should be made of the late Terry White and of the late Leslie Hart. Terry was the curator of the Hayes and Harlington Local History Society (HHLHS) for many years and he built up a valuable collection of material to which I have had free access. Leslie made his own collection of before and after photographs of Hayes. On his death his nephew generously gave his collection to me when it could so easily have been thrown away. Apologies are made to anybody or any organisation whose material I have inadvertently used without acknowledgement.

P. T. Sherwood
Harlington 2017

First published 2017

Amberley Publishing
The Hill, Stroud, Gloucestershire, GL5 4EP
www.amberley-books.com

Copyright © Philip Sherwood, 2017

The right of Philip Sherwood to be identified as the
Author of this work has been asserted in accordance with
the Copyrights, Designs and Patents Act 1988.

ISBN 978 1 4456 7404 9 (print)
ISBN 978 1 4456 7401 8 (ebook)

British Library Cataloguing in Publication Data.
A catalogue record for this book is available from the
British Library.

Origination by Amberley Publishing.
Printed in Great Britain.

Introduction

This book contains before and after photographs of Hayes and Harlington. The area covered is that of the Hayes and Harlington Urban District as it was created by the reorganisation of local government in 1930. This resulted in the merger of the two civil parishes, which before that time had no more of a connection with each other than they had with the other neighbouring villages. At the time of the creation of the UDC the boundaries of the civil parishes coincided with those of the ancient ecclesiastical parishes. These go back to Anglo-Saxon times, and the manors of Hayes (Hesa) and Harlington (Herdintone) are both mentioned in the Domesday Book of 1086. The Domesday Book also mentions the manor of Dawley (Dallega), which is historically within the parish of Harlington. In the mid-1930s the eastern boundary of Harlington was extended as far as the River Crane so as to include an area that is historically part of Cranford. In 1965 the urban district became part of the London Borough of Hillingdon. More recently the boundaries of the parliamentary constituency of Hayes and Harlington has also been extended. However, these post-1930 changes are outside the scope of this book.

The historic boundary between Hayes and Harlington follows the route of North Hyde Road from the River Crane in the east to Bourne's Bridge and it then follows the route of Dawley Road. This means the area to the north and east of these roads is, strictly speaking, in Hayes and those to the south and west are in Harlington. However, the growth of Hayes has blurred this distinction, and the M4 motorway, in the eyes of many (including the Royal Mail) is now considered to separate the two.

For this reason the book is divided into three parts. Part one deals with Hayes including most of the area north of the M4 motorway. Part two deals with Dawley, which has been given a separate chapter because its development is uniquely different from that of its neighbours. Part three deals mostly with Harlington to the south of the M4.

Two other books by me in this series – *Around Heathrow* (2012) and *Around Hayes* (2013) – also contain photographs of the area covered in this book, but the amount of duplication of material has been kept to a minimum.

Hayes

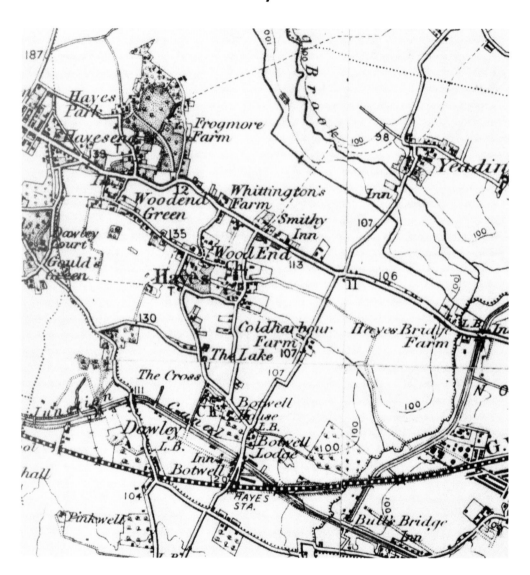

Hayes, c. 1900

Hayes village, then known as Hayes Town or Cotman Town, lies roughly in the centre of the large parish of Hayes. Nearby are the still separate hamlets of Hayes End, Wood End, Wood End Green and, in the extreme south of the parish, Botwell, which has since usurped the name of Hayes Town. More remote to the north-east is the hamlet of Yeading where, according to a nineteenth-century chronicler, 'Dirt, darkness and ignorance reign supreme'.

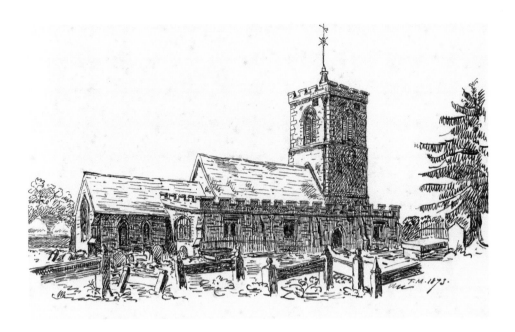

St Mary's Church from the North-east, 1873

The church (shown here in a drawing by Thomas Mills) has not changed its external appearance but the wooden graveboards seen in the foreground have long since gone. In the nineteenth century they were in common use as a much cheaper alternative to stone tombstones to mark a grave. They were placed longitudinally along the length of the grave with the name of the deceased painted on one side. Although much cheaper, the lifespan of a graveboard was very much shorter than that of a tombstone and all have since rotted away. The modern image shows St Mary's Church in 2014. The church dates from the early thirteenth century, although the tower is fifteenth century. (A. Wood)

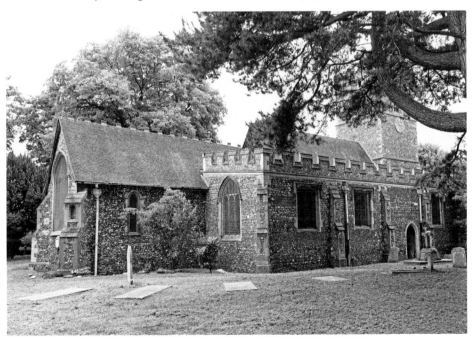

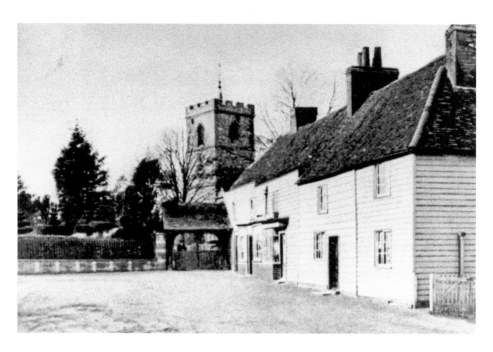

Church Green in the Early 1900s
The weather-boarded cottages adjoined the lyche gate of the church and were demolished in the 1920s. A pond behind the cottages was filled in at the same time, which presented the opportunity to open up the pleasant green area in front of the church, as seen below. The image below shows Church Green in 2001. (L. Hart)

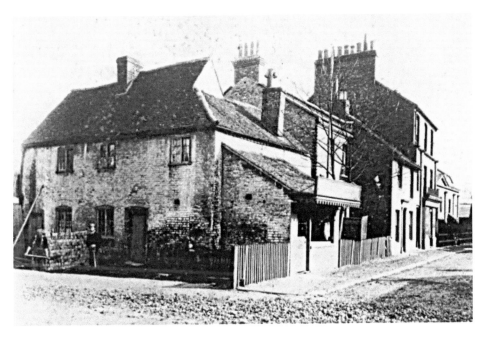

Church Road Looking South from the Junction with Hemmen Lane, 1903

The buildings in the foreground were demolished soon after this picture was taken and a new house and shop was built on the site bearing the plaque 'Drayton House 1904'. (L. Hart). The image below shows Church Road looking south in 2004 with Drayton House in the foreground. Apart from this the other buildings seen in the previous photograph have changed little in the succeeding years.

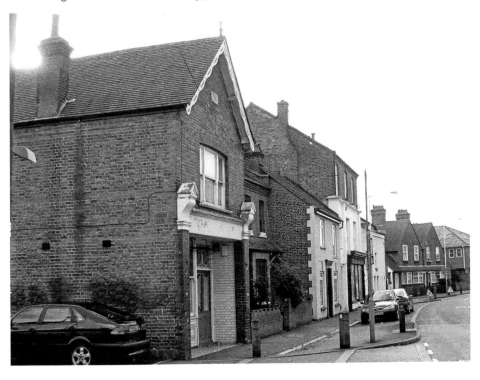

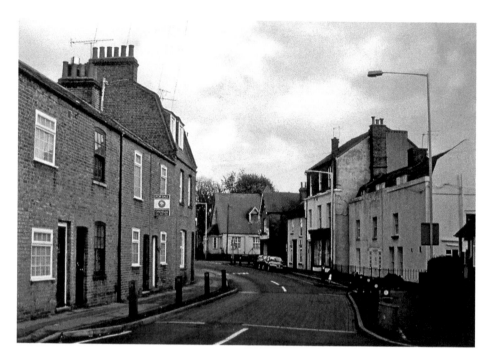

Church Road Looking North, 2004, and Hayes Steam Laundry

This shows the view from the opposite direction to the previous illustration. The buildings on the right appear in both. On the left is Hayes Town Terrace, the middle section of which dates from the early 1900s with later additions in the same style. Note how the building line follows the curvature of the road. The image below shows Hayes Steam Laundry in early 1900s. This building, which stood behind Hayes Town Terrace, had previously been a brewery but between 1899 and 1914 it had become the premises of the laundry. (L. Hart)

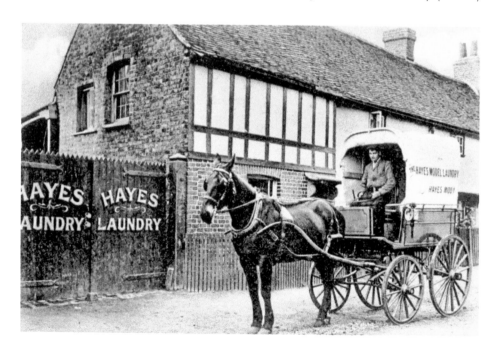

Freemans Lane, View to the West, Early 1900s

The lane once called Fleet Lane was renamed after John Neville Freeman, vicar of Hayes in 1792–1814. The brick house with the three chimney pots was once the cottage hospital and the farthest cottage was the famous scene of the notorious murder of a man by his wife in 1884 (HHLHS). The image below shows Freemans Lane in 2004. The houses seen in the above photo were demolished in 1959 and replaced with a small council housing development.

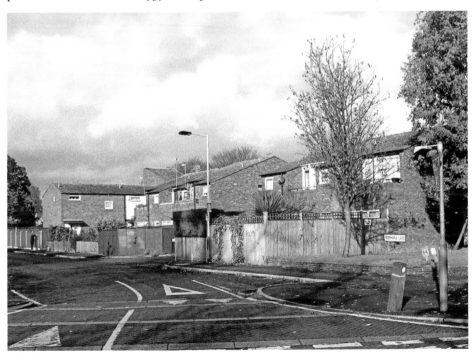

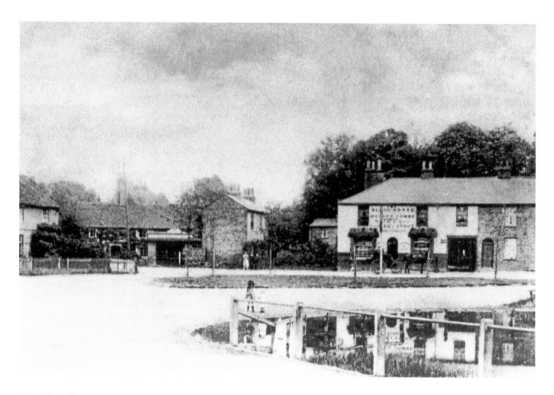

Wood End
The image above shows Wood End in the early 1900s with the Black Horse on the right of the photograph. (L. Hart) The image below shows Wood End in 2000. The pub and the pond seen in the previous photo have long since disappeared and this is the present-day view. (L. Hart)

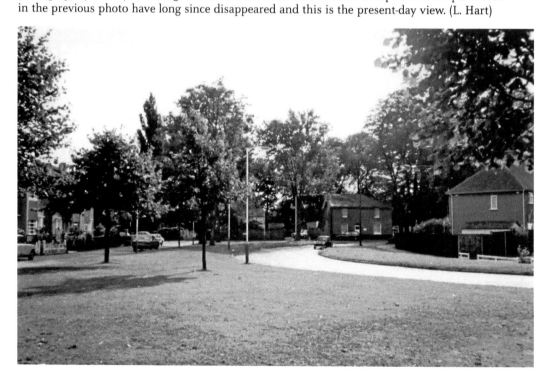

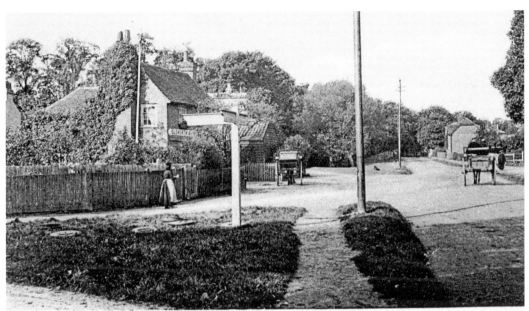

Hayes.- Wood End Green

Wood End Road

Wood End Road at the junction with Botwell Lane, looking west, in early 1900s. The Queen's Head can be seen on the left. The pub dated from the eighteenth century and in 1939 it was replaced with the building seen in the lower photograph (HHLHS), which shows Wood End Green Road looking west in 2010. The new pub opened in 1939 and changed its name to The Grange in 1986. It changed its name again to Tommy Flynns in 2011 and finally to the Blue Lagoon. However, the name changes were to no avail and it subsequently closed. It is currently (2017) boarded-up but it is proposed to convert the building into housing accommodation.

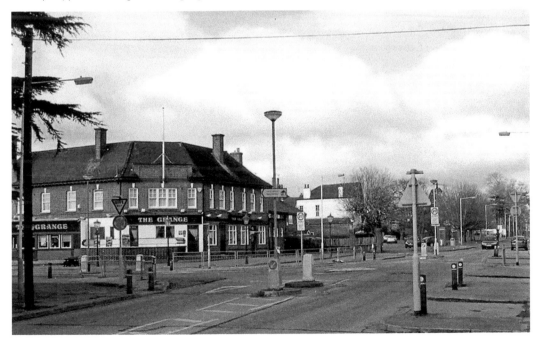

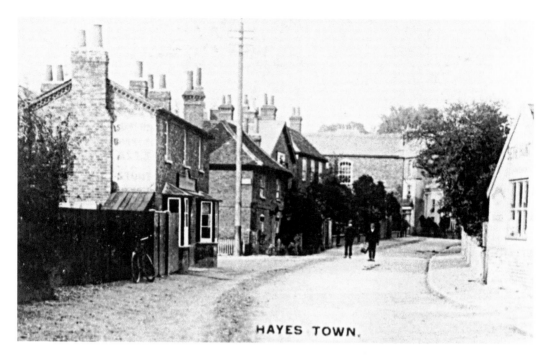

HAYES TOWN.

Church Road, Early 1900s
The view above looks north with the Royal Oak on the left at the junction with Freemans Lane. (L. Hart) Below, The Royal Oak, Church Road, is shown in 2000. The Royal Oak was rebuilt in the 1930s. After standing empty for many years it was demolished in 2004 and replaced with a block of flats in 2012. (L. Hart)

The Golden Cross, Botwell Lane, 2005

The original building dated from the mid-nineteenth century but it had been extensively remodelled and enlarged so that the building seen here bore no relation in appearance to the original. It was demolished in 2014 and replaced with the block of flats seen in the lower photograph (L. Hart), which shows the site of the Golden Cross in 2017.

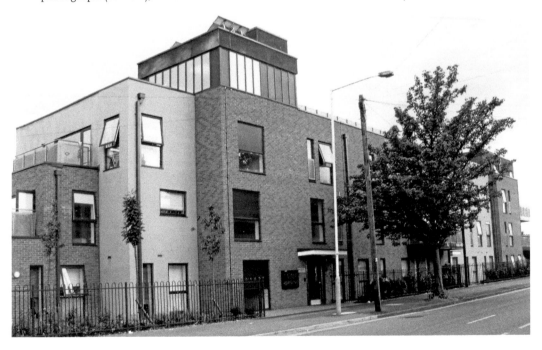

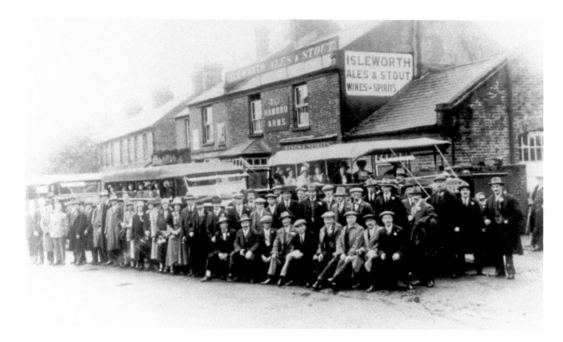

Hambro Arms, Dawley Road, 1920s

The photo above shows a large group outside the Hambro Arms about to set out on a coach outing. Such so-called 'charabanc outings' to the south coast were very popular at the time (HHLHS). Below, the former Hambro Arms, Dawley Road, is shown in 2017. The name was changed when it became a pub-restaurant but it did not flourish and plans have been made for its demolition for housing development.

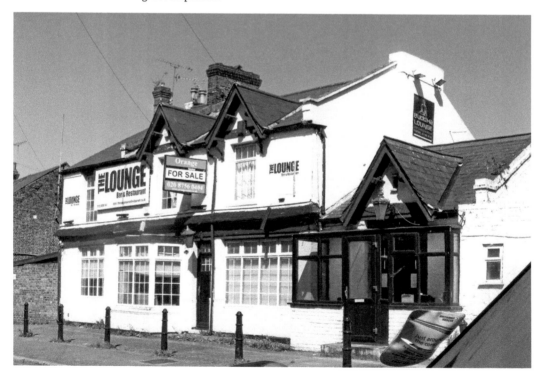

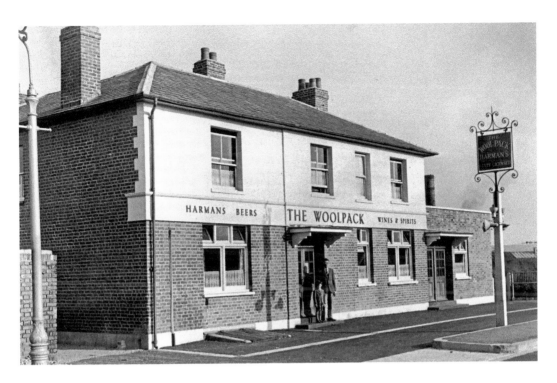

The Woolpack, Dawley Road, 1960

This pub, which dates from the mid-1800s, stands all alone on the east side of Dawley Road. Paradoxically the fact that there are no houses in its immediate vicinity has helped it survive in its new format (*see* below) (HHLHS). The pub and its name seemingly survives with little change in 2017. However, it now operates as a 'gentleman's club' under the name 'Inhibitions'.

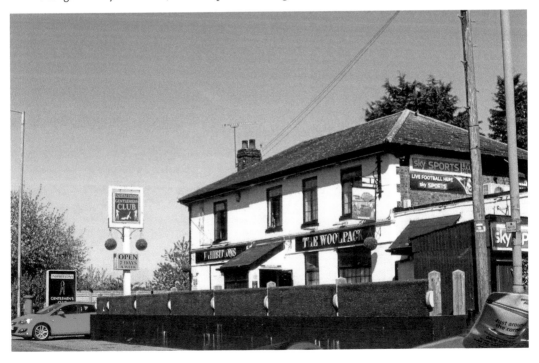

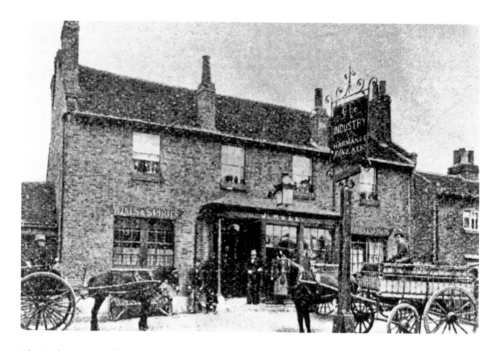

The Industry, Yeading Lane, Early 1900s

The Industry dated from the early nineteenth century and was jokingly said to be one of the three pubs in Yeading named after trees – the other two being the Willow Tree and the Walnut Tree. It was demolished in the 1930s and replaced with the new building with the same name seen in the lower photograph (HHLHS), which shows the Aroma, Yeading Lane, in 2017. The Industry closed as a pub and the building seemed to be scheduled for demolition. However, it has been revivified as a restaurant under a new name (S. Wood).

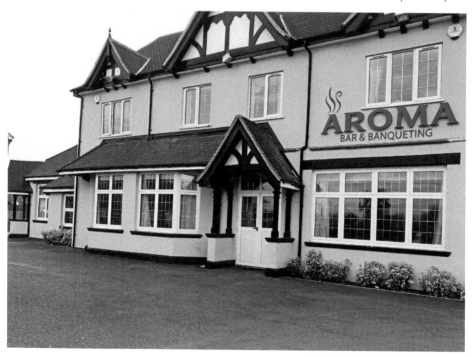

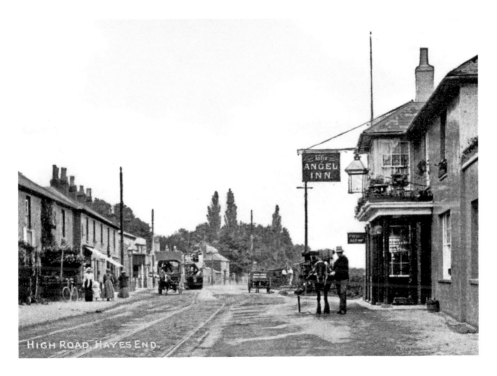

Uxbridge Road, Hayes End, Early 1900s
The view is to the east with The Angel public house on the right. This dated from the early 1800s and was demolished in 1926 to make way for the new building with the same name shown in the lower image (L. Hart). The Angel is a good example of the public houses that replaced the original buildings in the interwar years, so much so in fact that it has been given a Grade II listing on account of its architectural merit. (A. Wood)

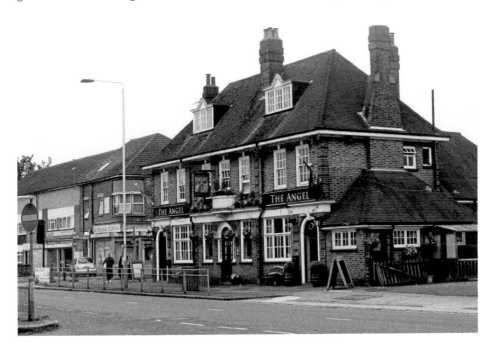

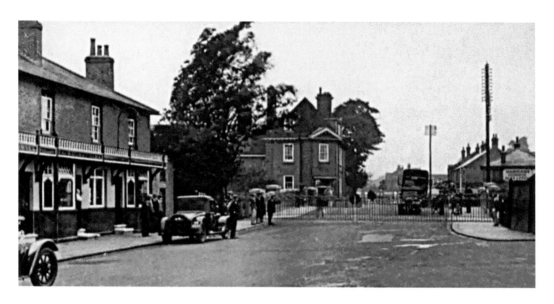

Station Road from the Canal Bridge, 1920s

On the left of the image above is the Railway Arms, which was demolished in the 1980s. To its right is the original Barclays Bank building, which has since been replaced with the building seen in the lower photograph. At the extreme right is the Old Crown, which is now the sole remaining traditional pub in the immediate vicinity (L. Hart). The image below shows Station Road from the canal bridge in 2017.

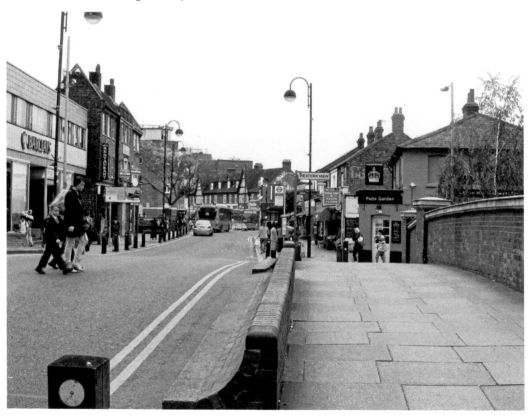

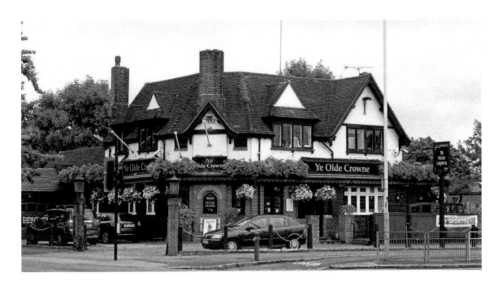

Ye Olde Crowne, Uxbridge Road and Bootlaces, Coldharbour Lane 2017

This pub was built as a replacement to the one simply known as The Crown, which stood in Church Road close to the junction with Church Green and closed in 1928. Its replacement occupies a prominent position at the junction of Lansbury Drive with the Uxbridge Road and despite its name it is in fact a good example of one of the many pubs that were built in the interwar years. It should not be confused with its near namesake The Old Crown in Station Road (page 18), which does have some claim to antiquity. (A. Wood) The image below shows Bootlaces. While the area was losing its traditional pubs such as the Royal Standard, it gained two in Coldharbour Lane in the form of shops that were converted to pub-restaurants. These put as much emphasis on selling food as they do on selling alcoholic drinks. One example is that shown in this photograph and another is the Botwell Inn shown on the next page.

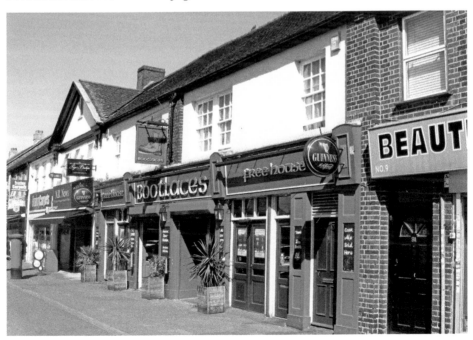

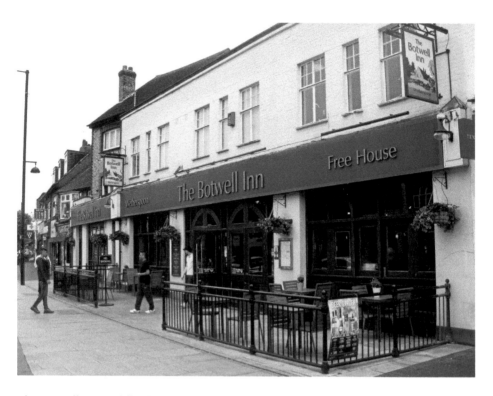

The Botwell Inn, Coldharbour Lane, 2017

This is another example of a pub-restaurant. The premises had previously been Moore's furniture shop (*see* below), which on closure was bought by J. D. Wetherspoon for conversion to the Botwell Inn. (A. Wood) The image below is Moore's furniture shop, Coldharbour Lane, shortly before closure. Hayes at one time had several family-owned shops such as this but sadly none now survive. However, the premises survive in a recognisable form as the Botwell Inn (*see* upper photograph). (L. Hart)

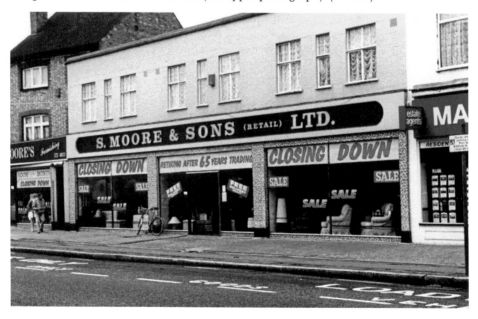

Golden Crescent, c. 1910

This view is to the east and the building on the left is the Botwell Mission Hall. On the 14 March 1896, the second anniversary of the death of her husband Mr E. H. Shackle, Mrs Emily Shackle laid the foundation stone of a Mission Room to be erected in his memory. However, the rapid growth of Botwell soon made the hall inadequate for church worship so steps were taken to erect a church on a site in Station Road to be called St Anselms. The Botwell Mission Hall was bought by Middlesex County Council in 1932 and was enlarged to become Hayes Library, which formally opened on 18 November 1933 (*see* below) (HHLHS). It was closed in 2010 when the new library opened in Botwell Green. The building has since been adapted for residential accommodation. The image below shows the library in 1986. (L. Hart)

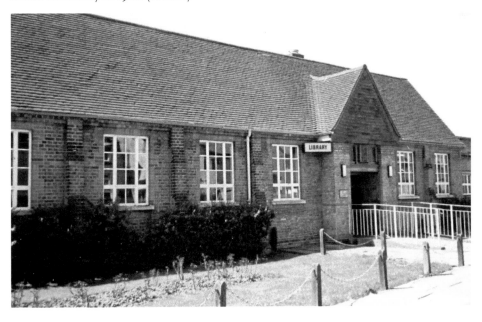

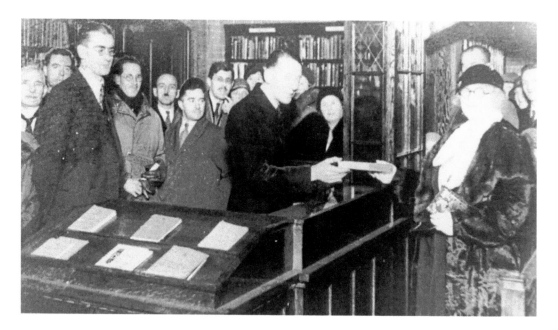

Formal Opening of Hayes Library by Mrs (County Aldderman) Baker, 14 November 1933

The opening ceremony of the Hayes Library represented the culmination of ten years of library activity in the district, which had begun in 1923 when a small branch was established in the old Clayton Road School (HHLHS). The image below shows Botwell Green Leisure Centre and Library in 2012. The new library forms part of a complex that also includes a swimming pool and a gymnasium. As soon as it opened the old library in Golden Crescent and the swimming pool in Central Avenue was closed. The swimming pool was subsequently demolished to make way for the supermarket that is currently (2017) being built on the site.

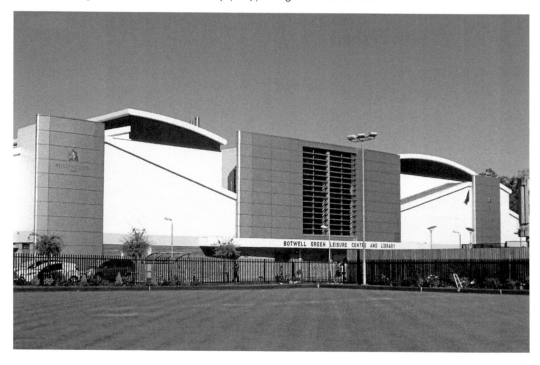

Hayes Labour Party Office, Pump Lane, c. 1960

The old Labour Party office in Pump Lane, seen in this photograph, was demolished in late November 2013 by which time it had become very dilapidated. It was a prefabricated corrugated-iron building of a type known as a 'tin tabernacle', which were much favoured by various Christian denominations on account of their relatively low cost and ease of erection. This particular tabernacle had started life in 1913 as a precursor to St Anselm's Church in Station Road. When the present St Anselm's came to be built in 1929 it was bought by the Labour Party and re-erected on the site in Pump Lane (HHLHS). The image below show the office in 2017. The prefabricated building seen on the left replaced the tin tabernacle seen in the previous photo.

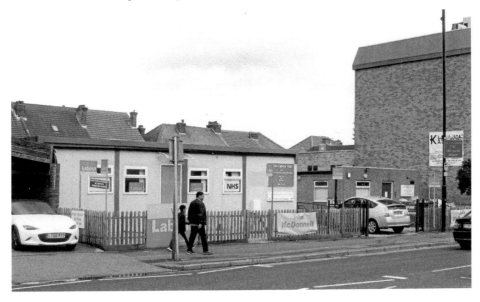

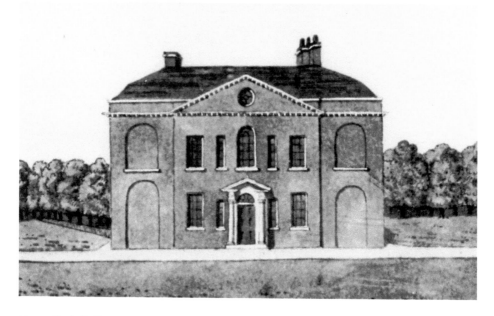

Hayes Park Hall

Judge Heath Lane in Hayes runs for around half a mile linking Botwell Lane to the east with Dawley Road in the west. It is named after John Heath (1736–1816) a High Court judge who lived in a house known as Hayes Park Hall, which stood midway along Judge Heath Lane on its northern side. Heath became chiefly known as a judge in criminal trials with a reputation for severe sentencing. He held the view that 'there is no regeneration for felons in this life, and for their own sake, as well as for the sake of society, I think it is better to hang'. An absurd story has developed in the locality that the hamlet of Heathrow (where the airport is now) was named after him, but the name is recorded from long before his time and Heath had no connection of any kind with Heathrow (HHLHS). The lower image shows Park Farm replaced Hayes Park Hall in the early 1800s but in turn has long since been replaced with modern developments. (HHLHS)

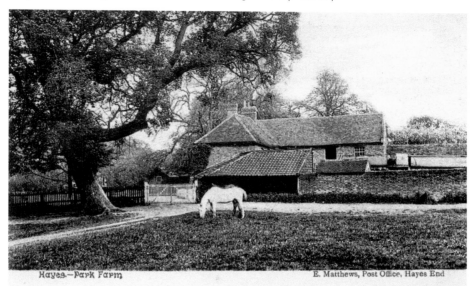

Hayes.—Park Farm E. Matthews, Post Office, Hayes End

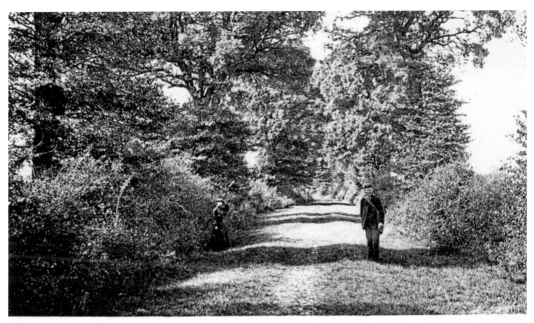

Hayes.—Judge Heath Lane

Judge Heath Lane, Early 1900s and 2005

Judge Heath Lane in the early 1900s. The shadows suggest that the photograph was taken at midday and that the view is to the west. At the time the view was still much the same as Judge Heath would have known it (Uxbridge Library). The scene has changed so much that it is hard to believe that this and the previous photograph were taken from the same vantage point.

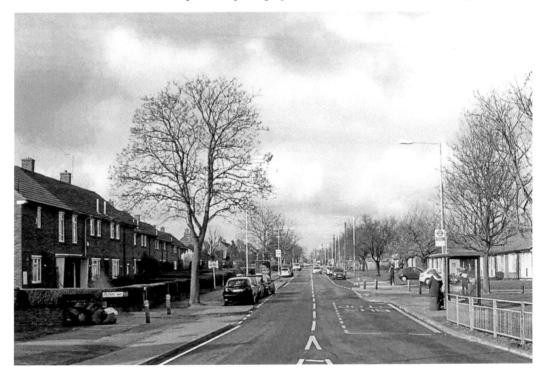

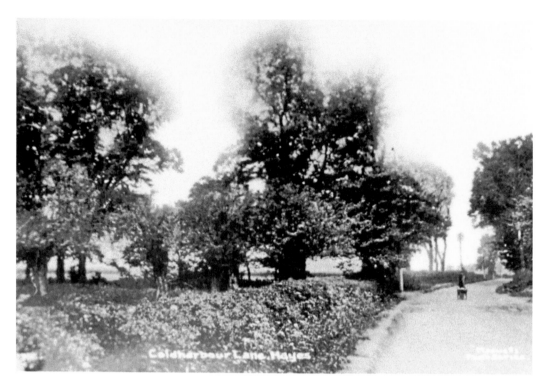

Coldharbour Lane

Coldharbour Lane in the early 1900s. At this time Coldharbour Farm (*see* below) and Coldharbour Cottages were the only buildings in the lane between Botwell Lane and the Uxbridge Road (L.Hart). The image below shows Coldharbour Farm in 1956. The farmhouse dated from the eighteenth century and was demolished soon after this photo was taken to be replaced by housing development. Until the 1920s it was the only building on the east side of the lane. (HHLHS)

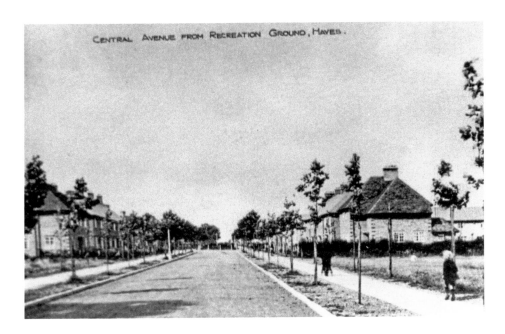

CENTRAL AVENUE FROM RECREATION GROUND, HAYES.

Central Avenue, Early 1930s

At the turn of the nineteenth century the population of Hayes was only 2,500 and it was still a rural community. By 1931 it had become heavily industrialised and the population had increased almost tenfold to 25,000. This rapid expansion caused a severe housing shortage and to help meet the demand Hayes UDC built 2,000 houses in a triangular area of land bounded by Church Road, Coldharbour Lane and Uxbridge Road. This became known as the Townfield estate, which is a good example of interwar municipal housing. The houses have a mixture of architectural designs with tree-lined avenues such as that shown in the photograph above. (L. Hart). The image below shows Central Avenue in around 2000. In the intervening years the trees have reached maturity and form an attractive feature. As a result the Townfield estate has been designated as an Area of Special Character. (L. Hart)

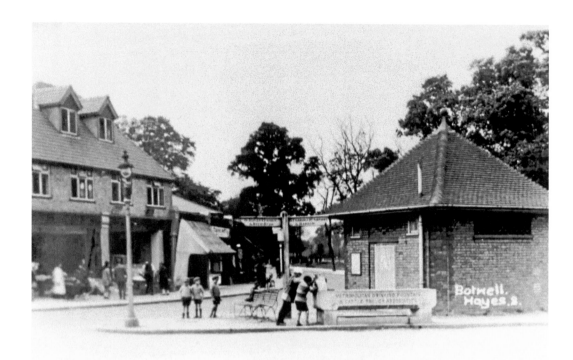

The Junction of Coldharbour Lane with Botwell Lane

The junction of Coldharbour Lane with Bowell Lane, above in the early 1920s and below in the 1980s. Were it not for the presence of the building on the left it would be hard to realise that the two photographs were taken from the same vantage point. This building was still there in 2017 but the adjacent building has been replaced by a four-storey block occupied by Specsavers and the Carphone Warehouse. (L. Hart)

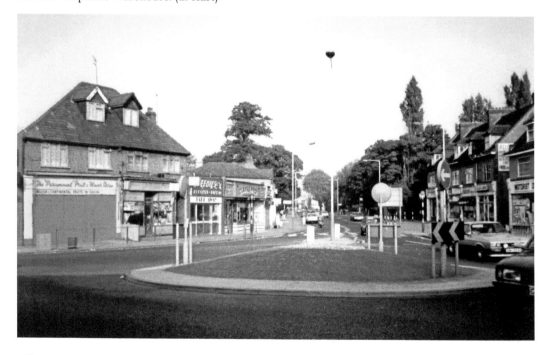

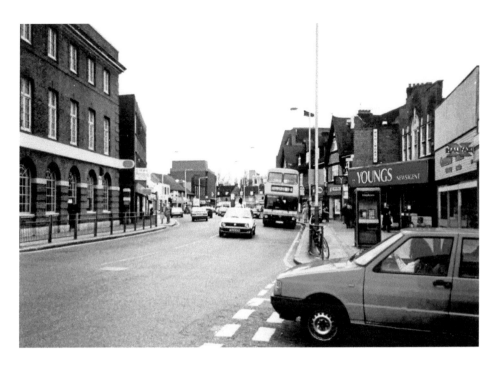

Station Road Shopping Centre, 1985

The heavy traffic through the shopping centre led to the demand for the construction of the Hayes Bypass. Construction of this from the White Hart at Yeading to the Cranford Parkway was completed in 1992 and this allowed the shopping centre to be pedestrianised as shown in the lower photograph (L. Hart). The opening of the bypass allowed the road through the shopping centre to be closed to traffic. This proved to be unpopular with the shopkeepers, who complained that it affected their trade even though it had been impossible to park when the road had been open to traffic. (L. Hart)

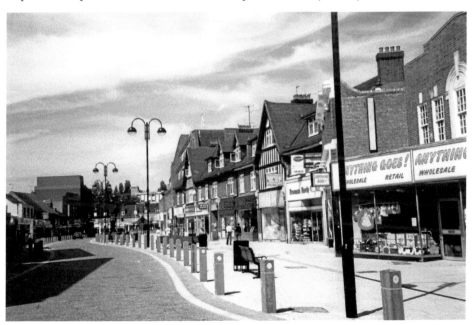

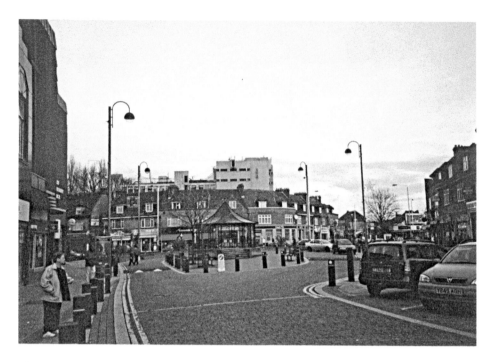

Shopping Centre, 2013 and 2017

To meet the criticism of the shopkeepers the road through the shopping centre was reopened so that cars could be parked in designated areas on one side of the road but through traffic was still prohibited. This proved to be an unsatisfactory compromise and in 2016 work began to reopen the road to through traffic. The road was reopened to traffic twenty-five years after it had been closed as part of the Hayes Town Centre Improvement Scheme. Whether or not this was really an improvement is open to question.

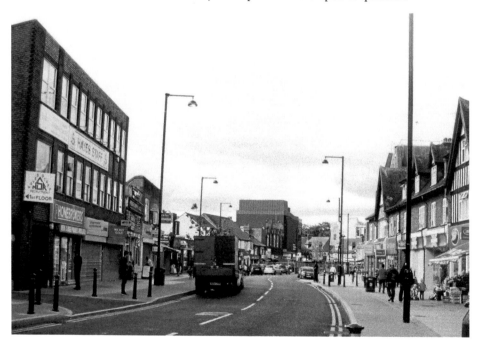

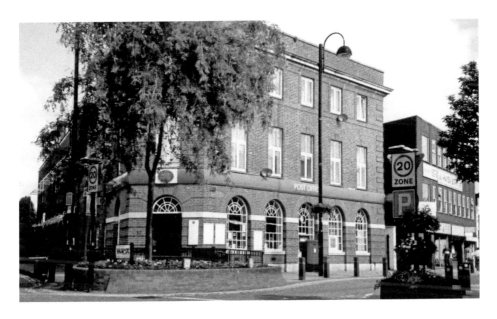

Post Office, Station Road, 2000, and Woolworths, 2009

Most of the buildings in the shopping centre and Coldharbour Lane date from the interwar years. Like most towns of any size Hayes had a large purpose-built post office, which also included a sorting office at the rear of the building. The sorting office was moved to a new site in Silverdale Road in the 1980s. The post office closed in 2010 when its business was transferred to part of the shop of WHSmith further along the road. The building survives unchanged in appearance and now contains a doctor's surgery and an NHS clinic (L. Hart). The image below shows Woolworths, Station Road, shortly before closure in 2009. Many chain stores such as Woolworths came to the shopping centre in the 1930s but few now remain. Woolworths was one of the most popular. It sold a wide range of household goods with nothing costing more than 6*d* (2.5p). On closure the shop became a 99p store and is now (2017) a branch of Poundland. (L. Hart)

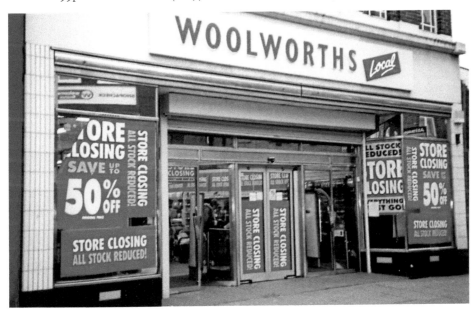

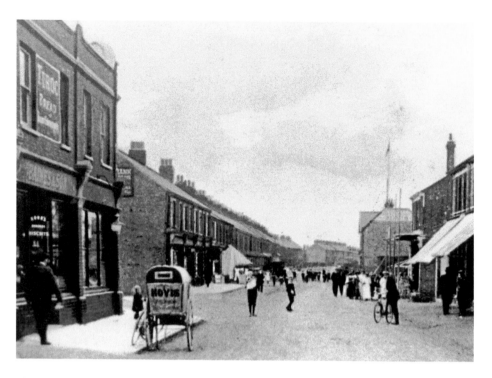

Clayton Road, Early 1900s

The road links Station Road with Dawley Road and was originally built to provide access to brickfields in the area owned by Thomas Clayton – hence the name. The brickfields were followed by the industrialisation of the area between the canal and the railway line (*see* page 36). Factories were built at the far end of the road and houses for the factory workers at the Station Road end, as seen in the photograph above. (L. Hart) Very little has changed in the appearance of the road over the past 100 years. (L. Hart)

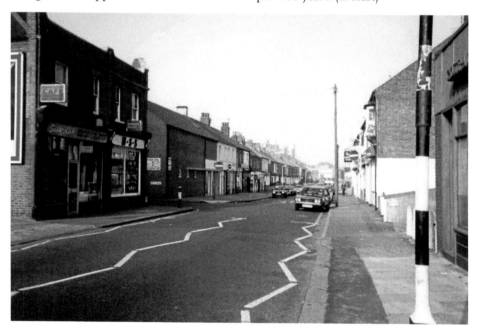

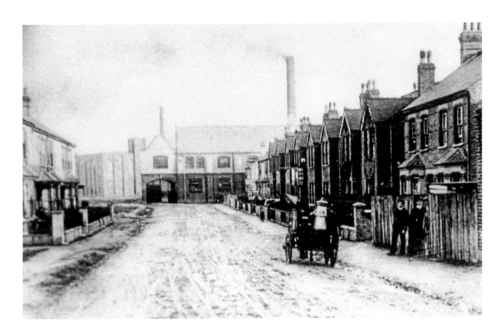

Silverdale Road in the Early 1900s

This view is from Station Road but access to Silverdale Road was subsequently blocked off when Crown Close became the through route for buses as a result of the closure of the road, through the shopping centre, to traffic in the early 1990s (*see* page 31). The factory building that can be seen at the end of the road belonged to the X-Chair Co. (L. Hart). Below, the entrance to Crown Close in 2017 can be seen. This was the original entrance to Silverdale Road from Station Road. Council house development seen in the background now occupies much of the area of the previous photograph.

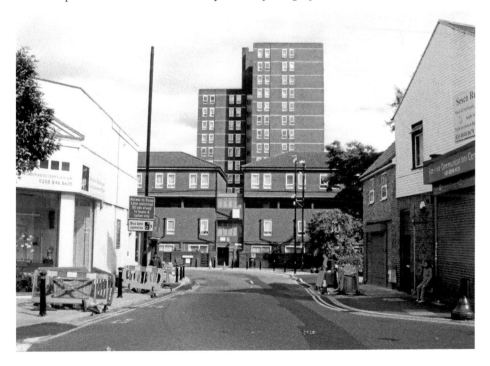

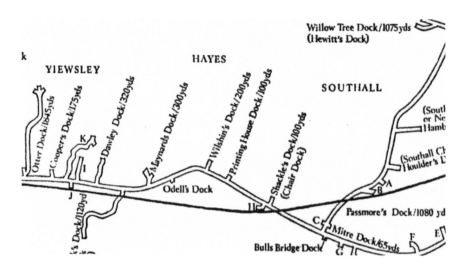

Map Showing the Docks Leading from the Canal to Brickfields in the Area
The Grand Junction (now Grand Union) Canal was opened to traffic through the area in 1794, The presence of brickmaking material along the route of the canal and the ready means of transporting the bricks by canal to the metropolis led to a large area of land that was close to the canal between Yiewsley and Hayes being given over to brickmaking. The docks were cut to provide access into the brickfields between Yiewsley and Hayes and at Yeading. This meant that barges could be readily loaded with bricks and taken by water to central London. On their return journey they could be loaded with London's rubbish for disposal in the worked-out pits. (Map reproduced from *The Grand Junction Canal* by A.H. Faulkner (David & Charles, 1972).) Below, barges with rubbish from London arrive at Stockley in 1929. Once the brick earth had been worked out the underlying gravel was then excavated. The pits left by the removal of the brick earth and gravel were then backfilled with domestic rubbish brought by canal from London. The dumping was uncontrolled so that the land was rendered completely useless for any further development. The tips frequently caught fire, attracted vermin and were the source of many complaints, but tipping at Yeading did not stop until 1948 and it continued for even longer at Stockley (*see* also page 51). (WDLHS)

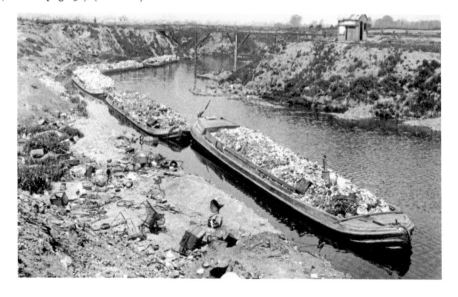

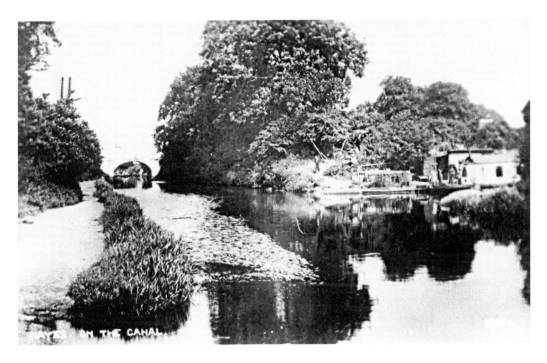

The Canal, Early 1900s

This view is to the west with the Dawley Road bridge in the distance and the entrance to one of the docks on the right. (HHLHS) The image below is a view to the west of the canal from Station Road Bridge. The only serious traffic now using the canal are pleasure craft, two of which are seen here. The view is deceptively peaceful since between Hayes and West Drayton the canal is mostly a tree-lined ribbon, behind which are many light-industrial developments. All of these turn their backs on the canal and in no way do they rely on it as a means of transport. (P. Sluman)

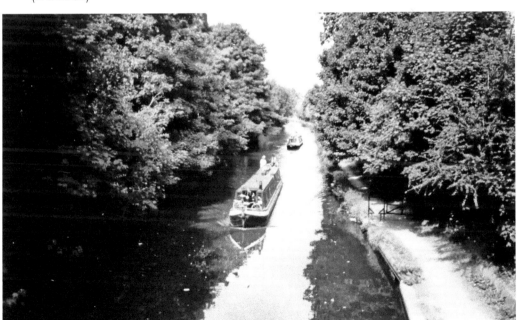

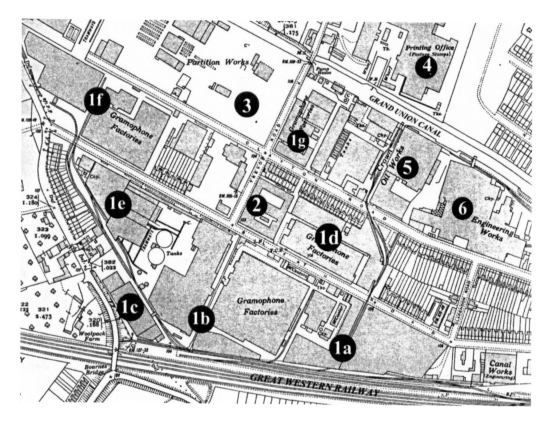

1935 Ordnance Survey Map

This map shows the position of the major factories. A former brickfield site in the Botwell area of Hayes bounded by the canal, the Railway, Dawley Road, and Station Road was acquired by the Hayes Development Co. in 1900 and in the next few years the area came to be occupied by many factories. Some of the firms moving to the site were only short-lived and by 1935 the Gramophone Co. (EMI) had taken over their premises and, as the map shows, had come to dominate the area.

1a–1g. Factory buildings belonging to EMI (Gramophonr Company)
2. EMI Head Office
3. Partition Works
4. Harrison's Printing Works
5. C. C. Wakefield Ltd (Castrol)
6. British Electric Transformers

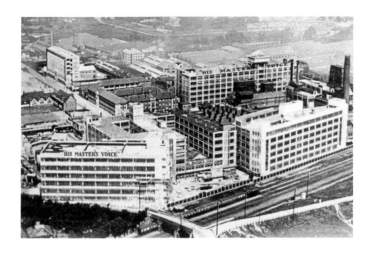

EMI Factory and Gramophone Co.

Above, an aerial photograph of the EMI factory complex from the 1930s can be seen. By then the Gramophone Co. had merged (in 1931) with the Columbia Graphophone Co. to become Electrical and Musical Industries (EMI), although for very many years after the merger the Gramophone Co. and its HMV trademark were much better known to the general public. Having started by merely making gramophones and gramophone records, the company greatly extended its activities into making radios, television sets, household appliances and electronic equipment. At its zenith it employed nearly 20,000 people in Hayes (HHLHS). The image below shows the trademark of the Gramophone Co. The company commissioned Francis Barraud, the artist of the original painting of Nipper the dog listening to his master's voice, to modify the painting so as to portray the dog listening to one of its gramophones. The painting then became the trademark of the company and attained such fame that the organisation became better known by the initials HMV. (EMI)

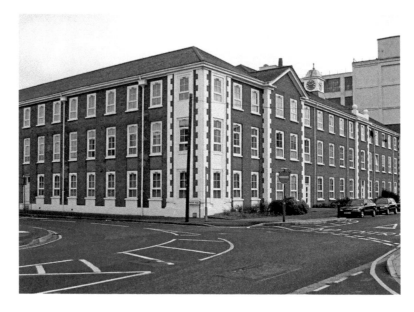

Former Head Office Building of the Gramophone Co., Blyth Road, and EMI Central Research Laboratories

The Gramophone Co. moved its head office from London to Hayes in 1912. The building also contained the recording studios of the company until they were transferred to Abbey Road in 1931. With the removal of EMI from Hayes the building was converted to hostel accommodation. The image below shows the EMI Central Research Laboratories, Printing House Lane in 1986. This is the only multistorey building of the company that no longer exists. It was demolished in the 1990s and replaced with a warehousing development. Throughout its existence EMI was heavily involved in research and the many achievements for which it was responsible included stereophonic recording, the CT body scanner, and improvements in radar. When the BBC started television broadcasts in 1937 it used a system developed by EMI, which manufactured all the equipment used by the corporation. (L. Hart)

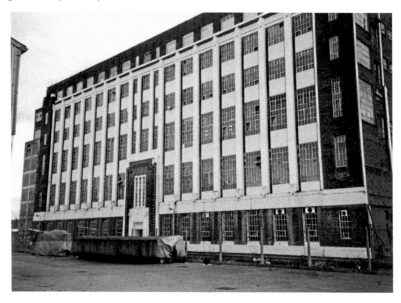

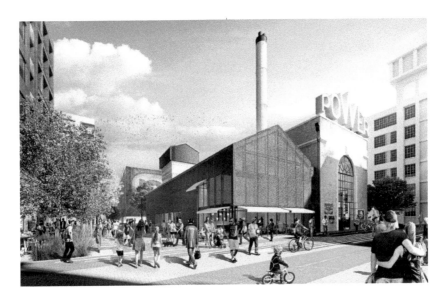

The Redevelopment of the EMI Site

An artist's impression of the redevelopment of the EMI site Throughout the 1980s EMI gradually reduced its actvities in Hayes until it no longer had a presence apart from the building containing its archives in Dawley Road. The factory buildings became vacant and many were vandalised. Planning consent was secured in April 2013 for a £250-million regeneration of the 17-acre site, which was to be called 'The Old Vinyl Factory', although much more than vinyl records had been made on the site. By 2017, 133 homes, a University Technical College for 800 pupils and 100,000 sq. ft of office building had been completed. Over the next four years it is estimated that the master plan for the site will deliver over 640 new homes, 550,000 sq. ft of offices, the University Technical College, a music venue and a three-screen boutique. (The Old Vinyl Facrory.) The image below is a view from the railway bridge in 2017, showing work on the redevelopment of the former EMI site.

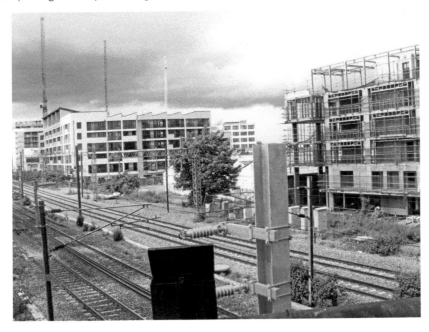

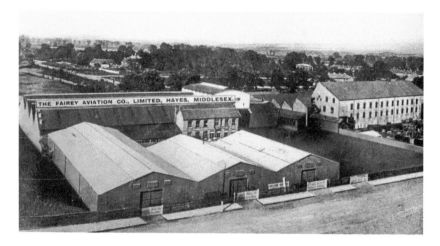

The Fairey Aviation Co.

The Fairey Aviation Co. was founded by (Charles) Richard Fairey in 1915 and began life in premises leased from the Army Motor Lorry Co. in Clayton Road, Hayes. The above photograph, dating from around 1916, shows the factory in Clayton Road but the name over the roof may be a photographic forgery because the factory did not belong to Fairey's, and similar photographs exist showing the name of the Army Motor Lorry Co., the actual owners of the factory, displayed prominently on the roof. Disputes between the companies led Fairey to do a 'Moonlight Flit' in which overnight he removed all of his equipment from Clayton Road to a site that he had acquired in North Hyde Road, Harlington. This site was subsequently developed as the headquarters and factory of the company. Because the company started life there the Hayes address was maintained, although strictly speaking it was in Harlington. (HHLHS)

The aerial photograph below (c. 1920) shows Station Road on the right before the houses that now line the eastern side of the road were built. At the time Station Road joined but did not immediately cross North Hyde Road. To reach the station it was necessary to make a sharp right turn and then left into what is now Old Station Road. What appears to be Station Road is in fact Albert Road with Elim Church on the left. The road then continues into Keith Road where only six pairs of semi-detached houses had then been built. (R. Henley)

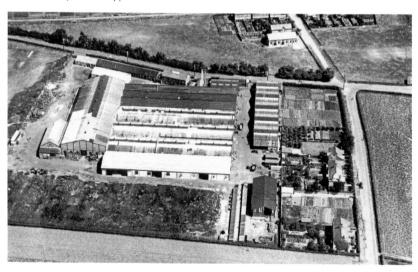

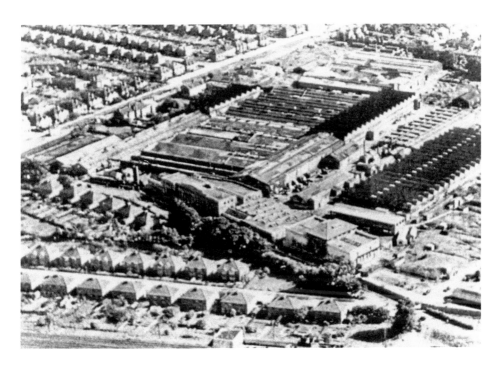

Aerial View of the Fairey Aviation Co.'s Factories, Late 1930s

The photo shows how the company had expanded so as to occupy most of the area bounded by North Hyde Road, Station Road, Redmead Road and Dawley Road. The view is to the south with North Hyde Road in the foreground (L. Hart). The photo below is a view of Station Road looking south from junction with North Hyde road in around 1960. The houses on the right were demolished soon after the photograph was taken. The adjacent building was the Fairey Aviation canteen (L. Hart).

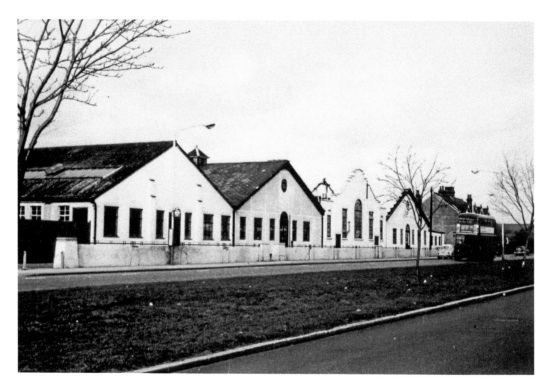

Fairey Aviation Co.

The view above shows the same buildings as in the previous shot but looking from the opposite direction. By this time Faireys had been taken over by Westland helicopters and the factory was closed in 1972. All the buildings were subsequently demolished. (L. Hart) An ASDA supermarket now occupies the site of the buildings seen in the previous photograph.

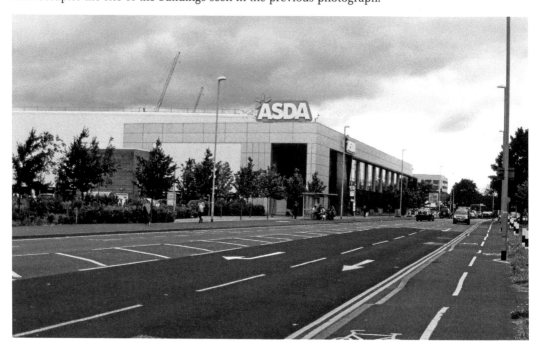

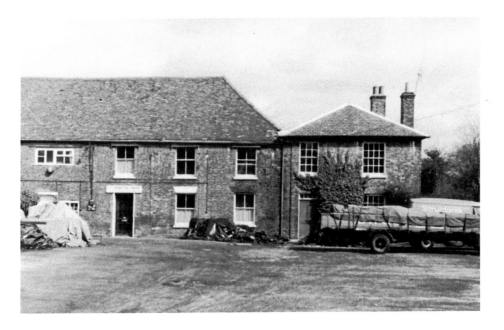

PLC Engineering Co., Eden Works, Uxbridge Road, 1972

Most of the large factories in Hayes were close to the railway and canal but throughout the area there were smaller enterprises such as PLC Engineering. The buildings seen in the photograph above stood just behind the 'Adam and Eve' and the large building on the left began life in the eighteenth century as the stables (with accommodation for ostlers, grooms etc.) of the roadside inn. By 1910 it was in industrial use and from 1930 it was the premises of the Patent Lighting Co. (later PLC Engineering). Following a fire in the 1970s the factory building was entirely rebuilt but the cottage on the right, which is a listed building, was restored (*see* below) (HHLHS) and is Eden House on Uxbridge Road. This early nineteenth-century house is hidden away behind the Adam and Eve. (A. Wood)

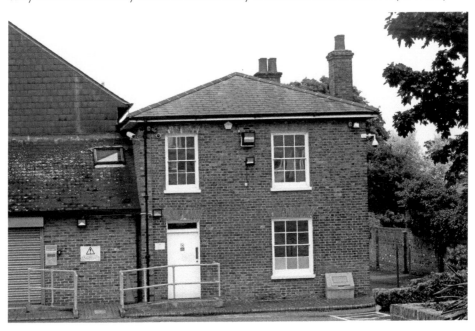

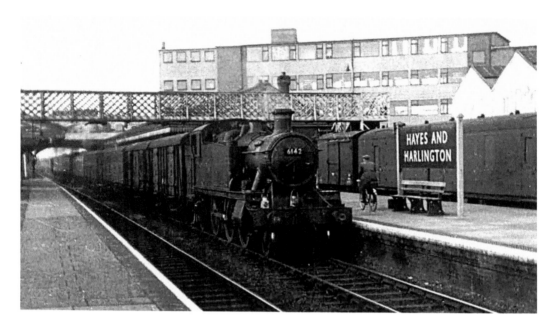

Hayes and Harlington Station, Early 1960s

The train above is seen passing under the Station Road bridge and in the background is the office block that adjoined the entrance to the station on the bridge. The railway through Hayes opened in 1838 but Hayes did not have a station until 1864, some twenty-five years after the neighbouring stations at Southall and West Drayton. The office block seen in the photo was demolished in 2015 prior to the redevelopment of the station as part of the Crossrail project. (*see* below) (L. Hart) The image below shows the funeral train of George VI passing through Hayes in 1952. Ever since the death of Queen Victoria the body of the late monarch has been taken by train through Hayes from London to Windsor. The photograph shows the train steaming towards Bourne's bridge with the EMI factories in the background. (Uxbridge Library)

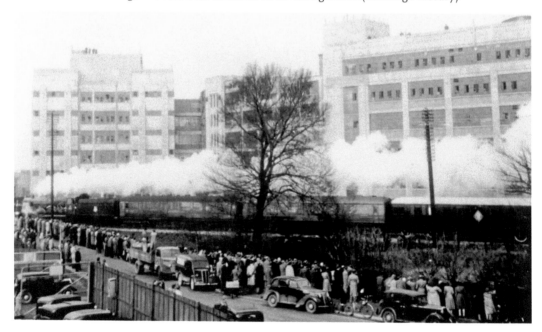

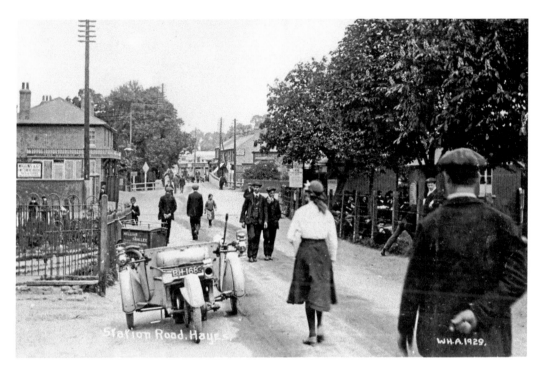

Station Road, Viewed from Outside Hayes Station

Two views showing Station Road from outside the station in *c.* 1920 (above) and 1990 (below). On the left in the above image is the Railway Arms and the bridge over the canal can be seen in the distance. (L. Hart) The office block on the right in the image below was demolished in 2015 prior to the redevelopment of the station. (L. Hart)

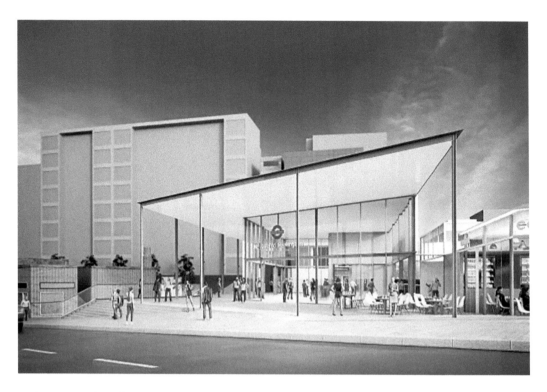

Artist Impression of Hayes Station
Here are two images showing an artist's impressions of the new station. As part of the Crossrail project the station is to be completely rebuilt. When completed by 2019 Hayes will have a frequent service into the city of London, Canary Wharf and beyond. (Crossrail)

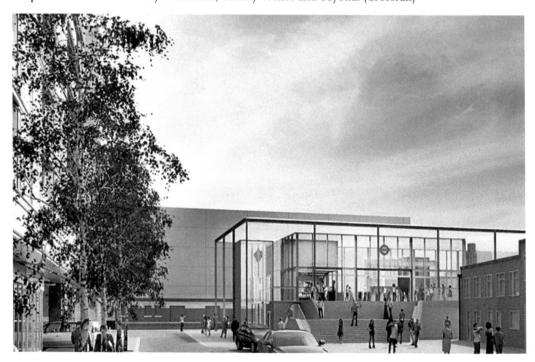

Dawley

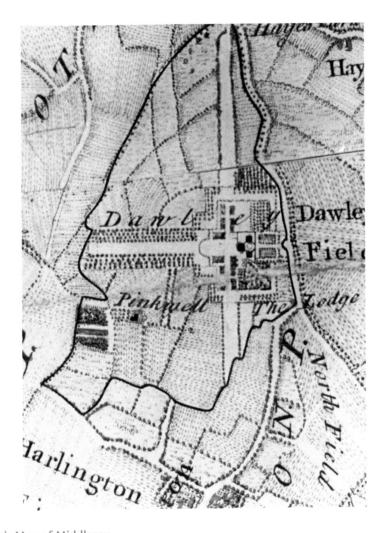

Rocque's Map of Middlesex

An enlarged portion of Rocque's map of Middlesex showing the Dawley area in 1754. This shows that the Dawley estate included most of the northern part of Harlington parish and that its boundary was almost contiguous with that of the parish. It also shows how the layout of the estate had changed following the alteration made during the tenure of Dawley by Lord Bolingbroke after he had bought it from the Bennet family. Apart from the avenues leading from the house much of the estate was by that time given over to agriculture. By the end of the eighteenth century most of what once had been the estate was sold off piecemeal to local farmers. From the mid-nineteenth century the land north of the canal was given over to brickmaking followed by gravel extraction.

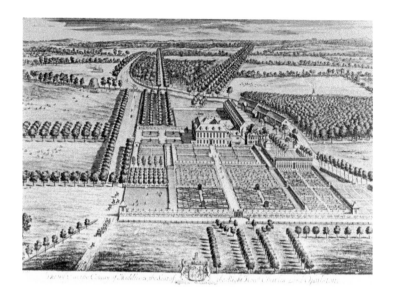

Dawley House

Dawley House in the late eighteenth century. The Bennet family owned the manors of Harlington and of Dawley from 1607 to 1724. The house shown in this illustration was built during the time that Sir John Bennet (1616–94) was lord of the manor. The inscription beneath the drawing reads, 'Dawley in the County of Middlesex the seat of the Rt. Hon. Charles, Lord Ossulston'. He was the son of Sir John Bennet who had been made Lord Ossulston. The road to the right of the house is Dawley Road, which was later realigned to its present route to be further from the house. In 1724 the Bennet family sold Dawley to Henry St John, Viscount Bolingbroke, who completely remodelled the house. The house later became the property of the Earl of Uxbridge and it was demolished in the late eighteenth century. All that now remains as a reminder is the boundary wall of the estate, which runs for around 1 mile on the western side of Dawley Road Below is a view of Uppark, Sussex. This property, now owned by the National Trust, was built soon after Dawley House and gives a good indication of what it must have looked like. This is more than fortuitous as Charles Bennet, the owner of Dawley, was married to the daughter of the Earl of Tankerville, who owned Uppark. On the death of his father-in-law, who had no male heir, Charles Bennet was allowed to become the Earl of Tankerville.

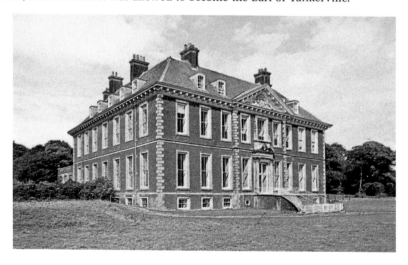

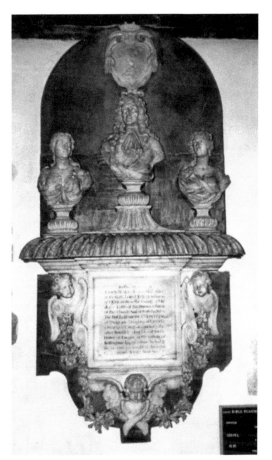

Bennet Monument, Harlington Church
The monument below shows Sir John Bennet (Lord Ossulston and lord of the manors of both Dawley and Harlington) in the centre with his first and second wife on either side. It was erected in 1686 during his lifetime as he did not die until 1694. (A. Wood)

Henry Bennet, the Earl of Arlington (1618–85) and the brother of Sir John, is the best-known member of the family. On the restoration of the monarchy in 1660 he entered politics and was created Lord Arlington in 1663 and Earl of Arlington in 1672. For his title he had fully intended to take the name of the parish, where he had lived in his youth but presumably, like so many modern-day locals, he failed to aspirate the first letter and so became Arlington. Despite his objections the College of Heralds refused to change the title from Arlington back to what he intended. He owned land in Mayfair and in Virginia and gave his name to Arlington Street and what was to become the Arlington National Cemetery in Washington. But for his sloppy pronunciation, these would both be called Harlington. (HHLHS)

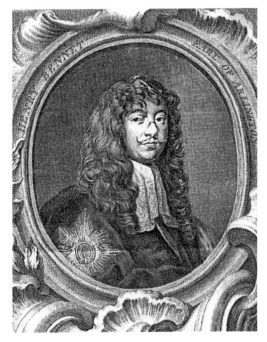

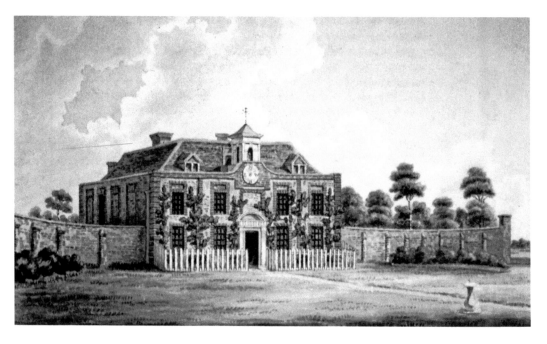

Dawley House, *c.* 1800

Apart from the building seen in this painting the greater part of Dawley House was demolished in the late eighteenth century but this house, which had been the dairy, survived and inherited the name. (HHLHS) Dawley House 1950. The house was bought by the Gramophone Co. (EMI) in 1929 and used by the company to simulate the use of its products in a domestic environment. It was demolished in the early 1950s. (HHLHS)

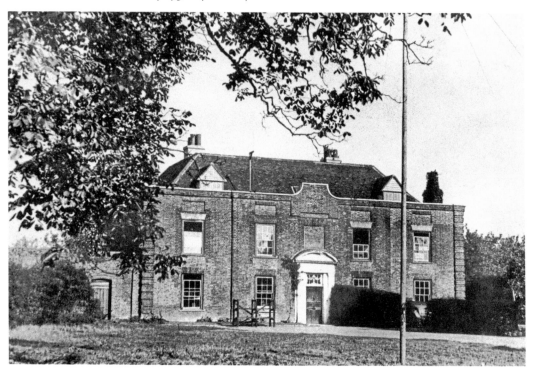

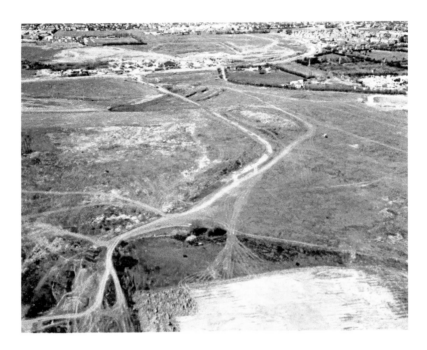

Stockley Road and Dawley Road, *c.* 1980

An aerial view of the land between Stockley Road and Dawley Road. It shows the utter devastation caused by the brickmaking and gravel industries and the subsequent uncontrolled backfilling with domestic waste (*see* page 49). It seems ironic that the parkland around Dawley House should have ended up looking like this. (Stockley Park plc) The image below shows Stockley Park in 2004. In the 1980s a programme of work began to convert much of the land between Dawley Road and Stockley Road into a country park and eighteen-hole golf course. To pay for these developments the southern part was converted into a business park with low-rise office buildings among newly created lakes and contoured landscape. This with the addition of extensive tree planting has transformed the area into something far removed from that shown in the photograph above. Dawley Wall, which once formed the boundary of the Dawley estate, now forms the eastern boundary of Stockley Park.

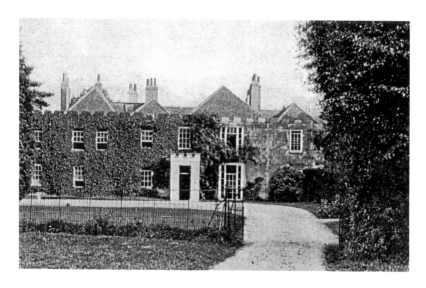

Dawley Court, Gould's Green, Early 1900s

This house is frequently confused with Dawley House, a much more important building about a mile to the south in the parish of Harlington. It was at the south-east extremity of Hillingdon close to a point where the parish boundaries of Hillingdon, Harlington and Hayes meet. It stood on a triangular site bounded by Harlington Road, West Drayton Road and Corwell Lane. Its original name had been Gould's Green House but it was renamed when it was acquired by the de Salis family in the late eighteenth century. The de Salis's owned the manor of Dawley in Harlington but never lived there and by then Dawley House had been largely demolished. It was probably because of this that they renamed their house – a matter for regret to local historians ever since. Sir Cecil de Salis, the last member of the family to live at Dawley Court, sold the house in 1929. It was demolished soon after and the site is now covered with houses. (Uxbridge Library) Below is an image of the former lodge house of Dawley Court, Harlington Road, in 2006. This is the sole remaining evidence of Dawley Court. When it was built in the mid-nineteenth century it stood at the southern end of the estate. Although attractive it now has a road on either side and looks rather out of place.

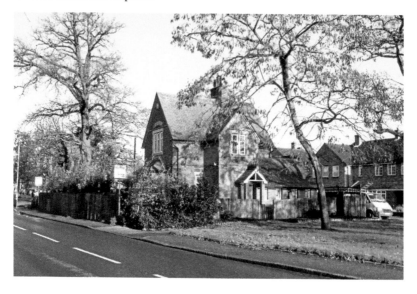

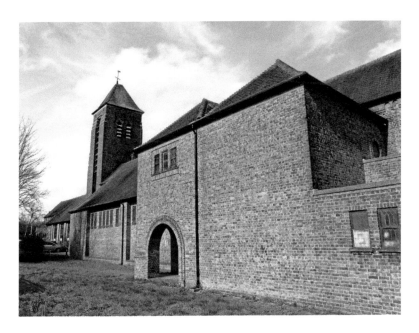

St Jerome's Church, Judge Heath Lane, 2017

As the population expanded in remote parts of the district away from the ancient parish churches of Hayes and of Harlington, the need arose to build more churches. These included St Anselm's in Botwell, St Edmund's at Yeading and St Jerome's at Dawley (seen in this photograph). It stands on the junction of Judge Heath Lane with Dawley Road. As it is on the east side of Dawley Road it is not strictly speaking in Dawley, although it is usually considered to be. When it was built the new ecclesiastical parish of West Hayes was created. (A. Wood) The foundation stone of St Jerome's Church is shown below. The church was built on land donated by Sir Cecil de Salis who had lived at Dawley Court until 1929. He wished to commemorate the death of his son Jerome de Salis, who had been killed in the First World War. It therefore seemed appropriate to dedicate the church to St Jerome. (A. Wood)

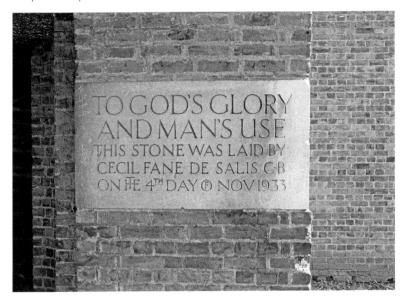

Bourne Avenue, 1984, and Pinkwell Cottages, 1996

While the area of the Dawley estate that was north of the canal and the railway line was given over to brick-making and gravel extraction, the southern part, which stretched as far as Cherry Lane, remained in agricultural production until well into the 1920s. After that time a housing development came to occupy most of the area between the railway line and Pinkwell Lane. Bourne Avenue and Bourne's Bridge are named after James Bourne, who farmed in the area in the mid-nineteenth century. Pinkwell Cottages are shown below. These cottages were built in 1909 to house some of the workers of Pinkwell Farm, which stood a little way to the north. At the time they were built they were the only houses in Pinkwell Lane. The farm was demolished in 1936 but the cottages, although much altered, are a reminder of the agricultural past of the area.

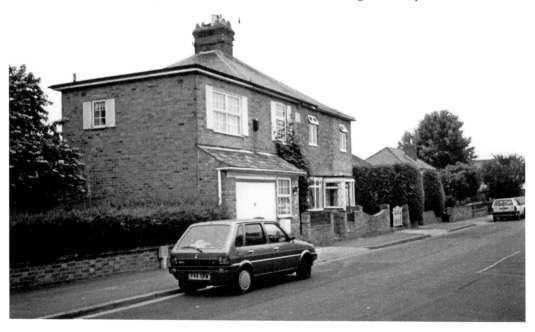

Harlington

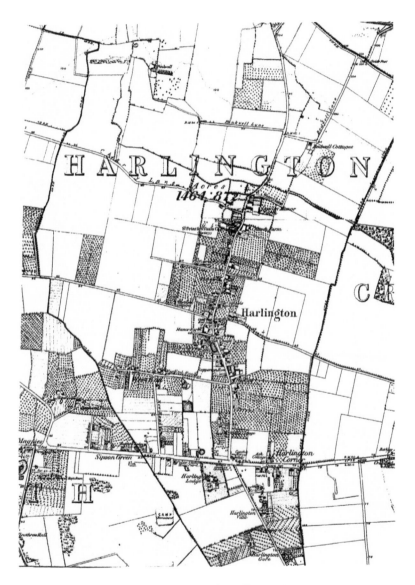

Harlington in 1865, Taken from a 25-inch-to-the-mile OS Map
The map shows most of the parish with the principal exception of the Dawley area in the north (*see* page 47). At the time west Middlesex was an important fruit-growing area and there were orchards on either side of the village High Street. The parish boundary took the form of an elongated diamond 3 miles from the extreme north to south but at its widest point only one mile from east to west.

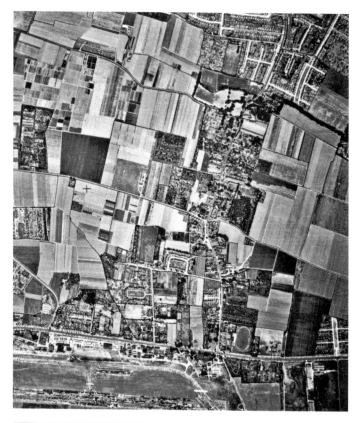

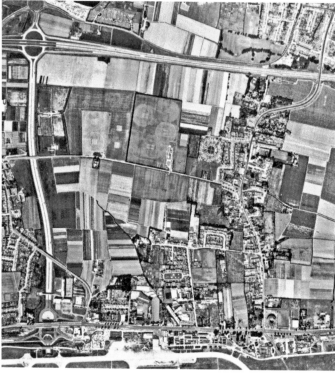

Aerial View of Harlington in 1949 and 1966
In 1949 most of the orchards had disappeared and much of the open land on either side of the High Street was in extensive cultivation. South of the Bath Road at the bottom, Heathrow Airport is still under construction. The 1966 image shows Harlington on the right with Sipson on the extreme left. The effect of the construction of the M4, the Airport Spur and the diversion of the High Street can be clearly seen. (GLC)

Proposals for the Construction of the M4 Motorway Apart from the motorway, the principal effect was the diversion of the High Street, but Cherry Lane and Watery Lane also had to be diverted (MOT). Below is a photo of the M4 motorway under construction in 1962. The view is to the east with the trees of Cranford Park in the background. (Transport Research Laboratory)

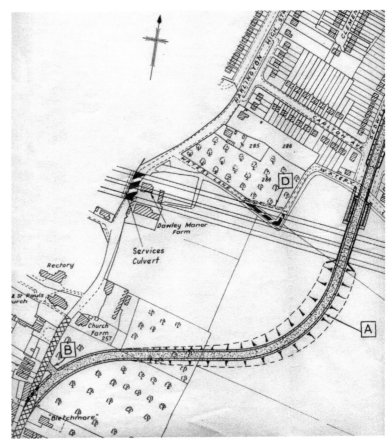

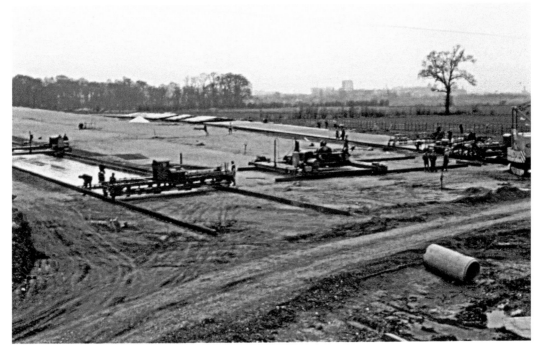

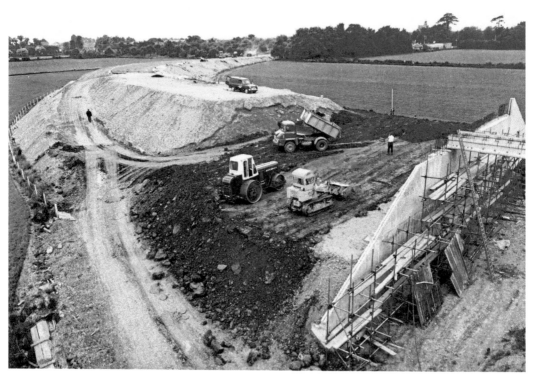

M4 Flyover

Construction of the M4 flyover and diversion of Harlington High Street in 1962 (Transport Research Laboratory). Below is a view from the M4 flyover bridge and the completed motorway from the same viewpoint as the above photograph.

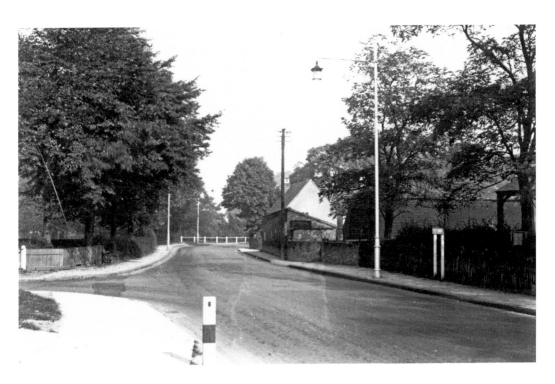

Northern End of High Street

The northern end of High Street at its junction with Cherry Lane in 1960. The building on the right is Dawley Manor Farm, which was demolished to make way for the M4. This turned the road into a cul-de-sac, as a result of which it was renamed St Peter's Way. The northern end of High Street (St Peter's Way) after it had been severed by the construction of the M4 is shown below.

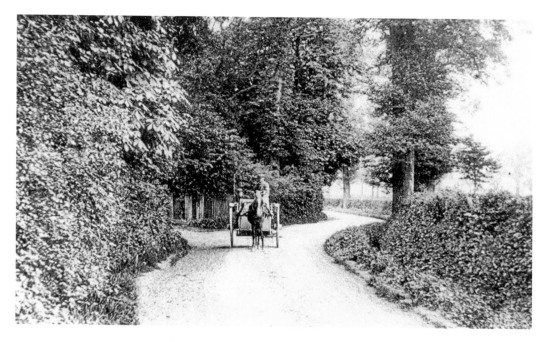

Cherry Lane/St Paul's Close

Cherry Lane in the early 1900s showing David Philp of Veysey's Farm on his milk-round outside the entrance to the Rectory (HHLHS). St. Paul's Close (*see* below), formerly Cherry Lane, in 2004. In the early 1960s the M4 cut across Cherry Lane leaving the eastern fragment at its junction with the former High Street as a cul-de-sac.

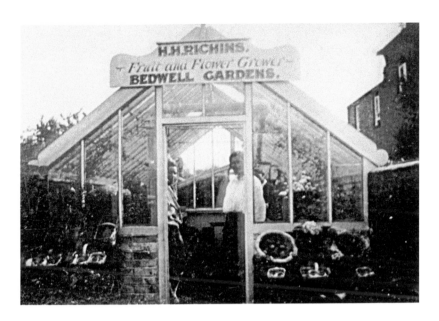

Bedwell Gardens

Bedwell Gardens in the late 1920s with Bedwell House on the right. When it was built in the mid-nineteenth century Bedwell House stood in splendid isolation south of the road (then known as Bedwell Lane) between Hayes and Harlington. The photograph above shows Henry Richens, the owner of Bedwell House, standing in the greenhouse with his married daughter Nellie Suter. (A. Richens). Bedwell Gardens in 2000 is shown below. In the mid-1930s the open land surrounding Bedwell House was turned into a wide dual carriage cul-de-sac leading from Station Road (formerly Bedwell Lane) with houses constructed on either side. In 1963 Station Road was extended southwards to run on an elevated section on top of Bedwell Gardens to take it over the M4 and connect with the diversion of Harlington High Street.

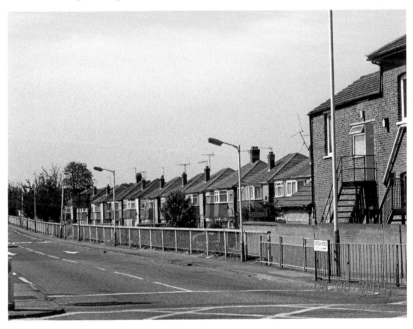

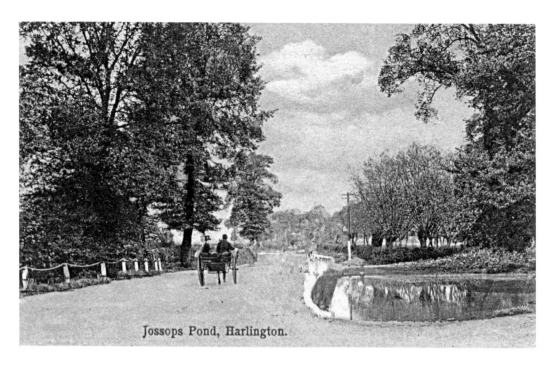

Jossops Pond, Harlington.

Jessop's Pond and Watery Lane

Jessop's (not Jossop's) Pond was just to the north of the present-day M4. It was fed by a stream (known as Frogsditch), which runs from the Pinkwell area through the Moats and then in parallel with Watery Lane to join the River Crane. The entrance to Watery Lane can be seen just to the north of the pond (HHLHS). The image below shows Watery Lane in 1991. The lane runs from what is now Shepiston Lane to Cranford Park. It is suitable only for pedestrians and originally offered a pleasant walk from Harlington High Street to the park. It was severed by the construction of the M4 so part of it had to be put in a tunnel. The photograph gives a false impression of rural tranquillity as in reality the lane is adjacent to the M4.

The Moats Recreation Ground, 1972

This ground gets its name from the fact that it contains the remnants of a moat fed by a stream (Frogsditch), which has now dried up. It is also known as the Sam Philp Recreation Ground as it was donated by the Philp family in memory of Samuel. The construction of the M4 in the early 1960s led to the loss of a portion of the recreation ground. To compensate for this loss and with the money received from the Ministry of Transport, the council bought a plot of land opposite to the Cottage Hospital in Sipson Lane (*see* below). Shortly after the photograph was taken the elm trees succumbed to Dutch elm disease. The image below is of a cricket match on Little Harlington Field, Sipson Lane, in 1975.

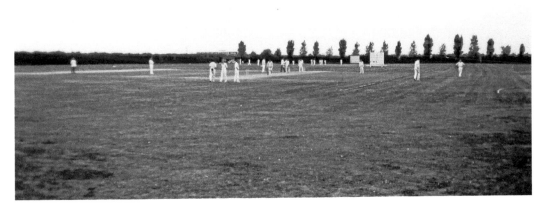

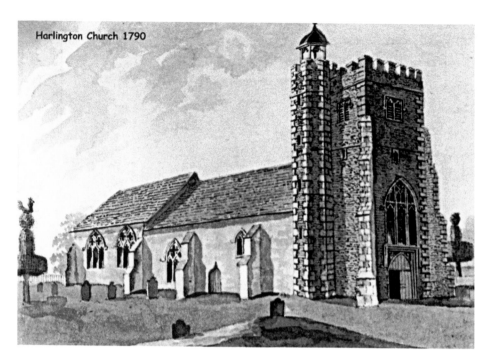

Harlington Church 1790

Harlington Church

A print of the north side of the church in 1790. On either side of the print are two yew trees totally out of proportion but confirming how they were cut in the eighteenth century (*see* page 66). The north side of the church is shown below in 2014. The photo shows how the church was enlarged in 1880 by the addition of an aisle and a vestry on its northern side. (A. Wood)

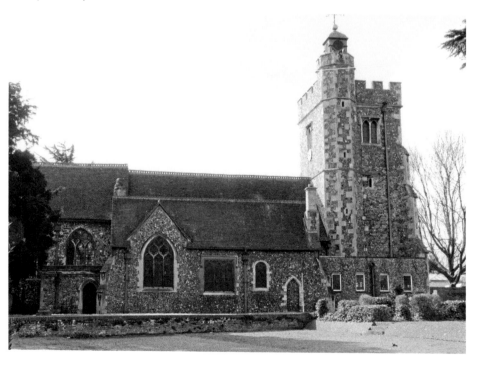

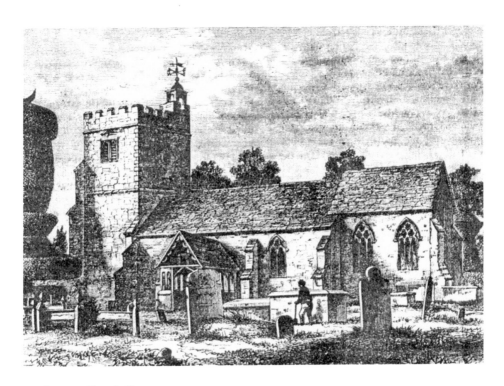

Harlington Church II

A view of the church from the south in 1803. The print shows that at this time the walls of the church were plastered. The plaster was removed and the flint walls exposed as part of the restoration in 1880. The yew tree can just be seen on the extreme left cut into a modified shape than had earlier been the case (from a print in the Gentleman's Magazine). The south side of the church is shown below in 1980. Apart from the removal of the plaster from the walls there have been few changes to the appearance of this side of the church.

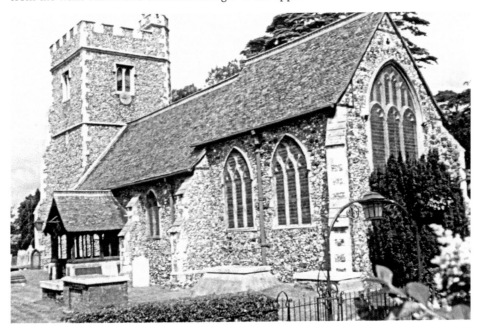

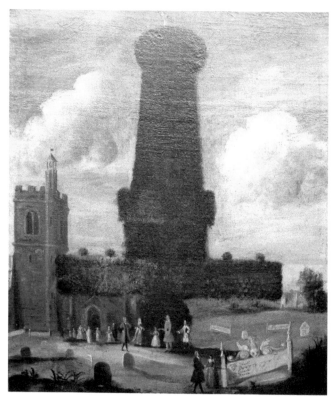

The Harlington Yew

The Harlington Yew in the late eighteenth century. This painting confirms other contemporary prints that the tree was indeed cut into this extraordinary shape. Tests on the tree have revealed that it is more than 1,000 years old (M. Grimston). The yew tree in 2005 is shown below. After 1825 the tree was allowed to return to its natural shape. It has been damaged by high winds on several occasions since then but has always recovered and continues to flourish despite its age.

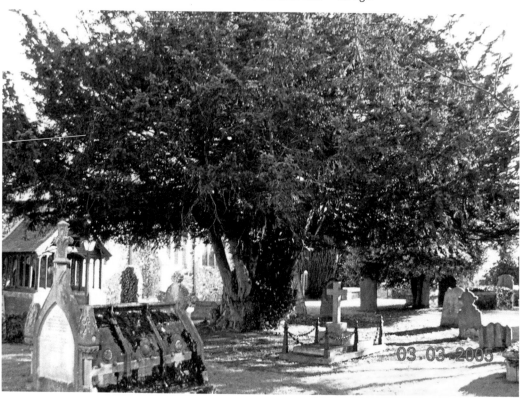

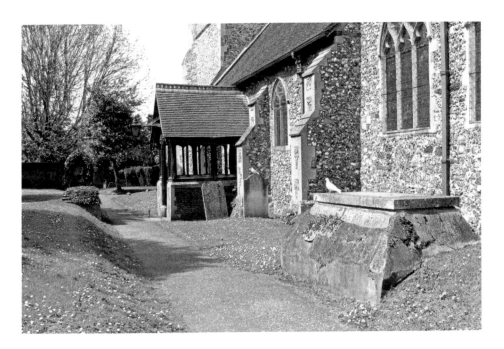

Harlington Church and Cherry Lane Cemetery

The pathway to the church entrance is at the original level but the land on either side is much higher. This is on account of the huge number of burials that must have taken place over the centuries in this part of the graveyard until it was closed in 1884. The graveyard was extended on three occasions but in turn the extensions were unable to cope. A similar situation occurred at Hayes, which led to the UDC acquiring land in Cherry Lane so as to open a cemetery (*see* below). The Cherry Lane cemetery was opened on the north side of the lane for burials in 1937 on what had previously been farmland. The western boundary of the site coincides with the Harlington parish boundary and long before it had been at the southern extremity of the Dawley estate (*see* the map on page 47).

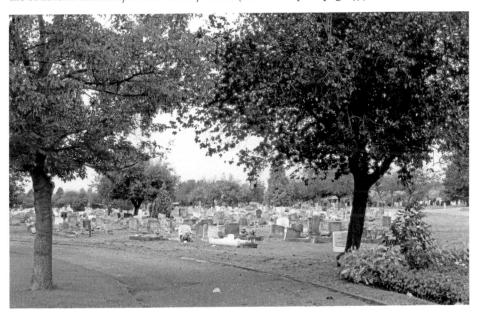

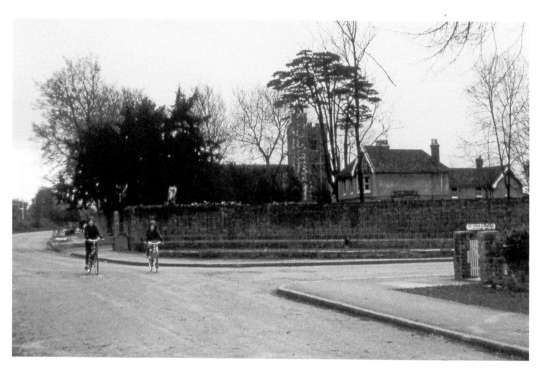

Church and Rectory

The church and rectory as seen from the junction of St Peter's Way and St Paul's Close in 1967. The rectory had a large garden with numerous trees, which occupied the area between the churchyard and St Paul's Close. The same view is shown below.. The old rectory was demolished in 1971 and houses built in its garden, which did irreparable damage to the setting of the church.

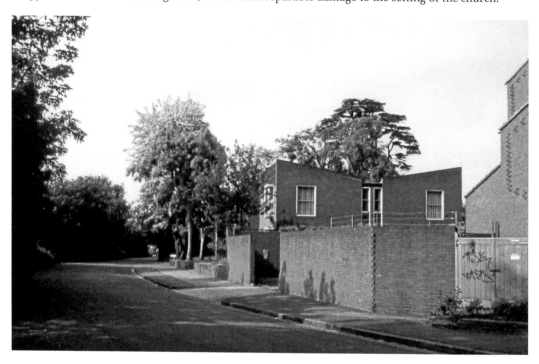

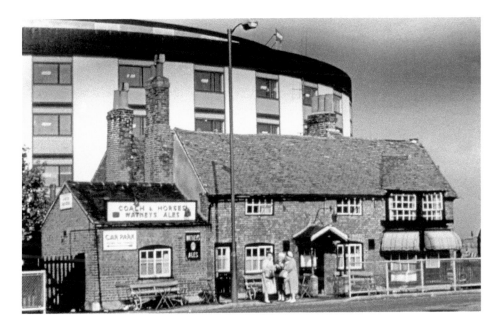

The Coach & Horses, the Ariel Hotel and The Crown

The Coach & Horses and the Ariel Hotel in 1960. The old coaching inn at Harlington Corner dated from the mid-eighteenth century. It was demolished just before the hotel was due to open. Of all the sites that could have been chosen for the hotel it was perverse to choose one that would lead to the destruction of the old inn. The hotel has since become the Holiday Inn. (HHLHS) This mid-nineteenth-century public house, The Crown, stood almost opposite to the Coach & Horses. Shortly before its demolition it was facetiously renamed The Office. In 1997 planning permission was given for a small hotel but although the Crown was demolished, no building has ever replaced it.

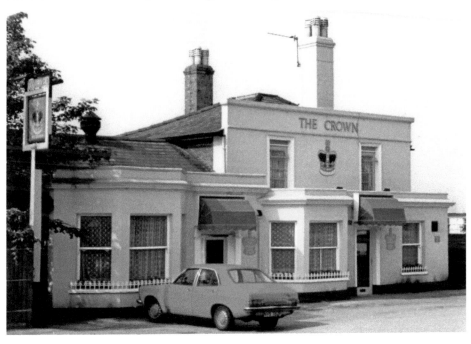

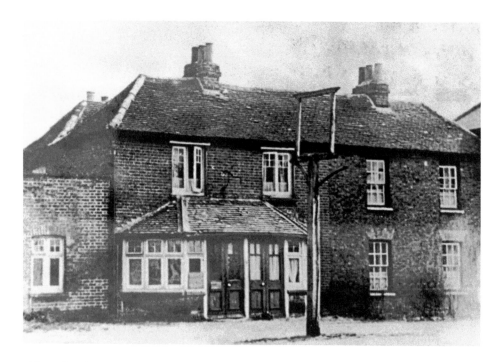

Wheatsheaf Cottages and the Wheatsheaf, High Street, c. 1930

The left-hand side of the building had been a public house not long before as evidenced by the style of the building and the empty inn sign. When the new Wheatsheaf was built on the opposite side of the road the name of the pub was changed to the Original Wheatsheaf and for a short time it continued to trade as a rival to its neighbour. It was demolished soon after this photograph was taken and Providence Court now occupies the site (HHLHS). The Wheatsheaf, High Street in 2012. This dates from the early 1900s and is now (2017) one of Harlington's three remaining public houses out of the original six.

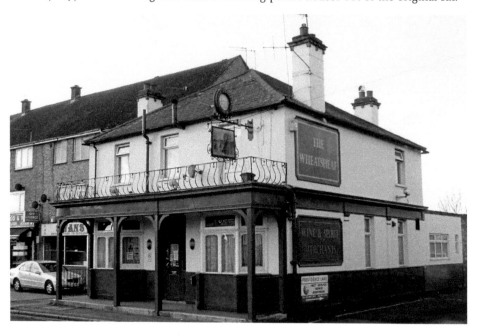

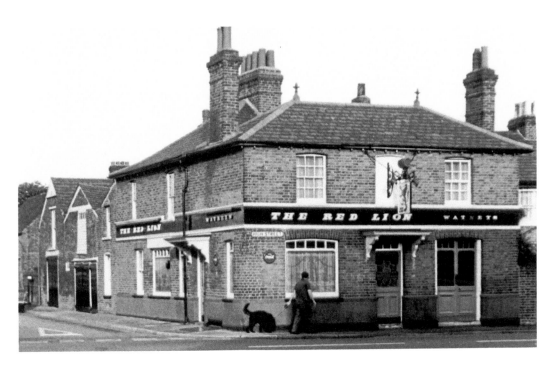

The Red Lion

The Red lion in 1969. This dates from the mid-nineteenth century and stands at the crossroads in the middle of the village High Street. The pub closed a few years before the 2017 photo (seen below) was taken. Having been a landmark for more than 150 years, it faces a very uncertain future.

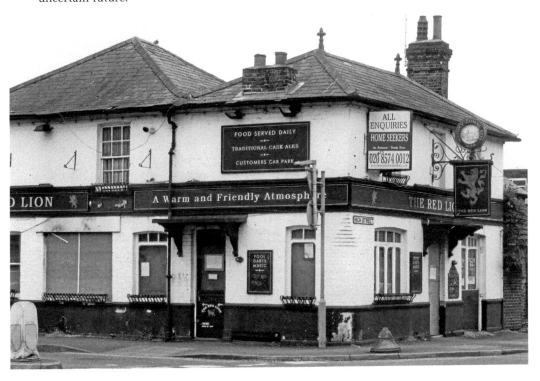

The Pheasant

The Pheasant dates from the mid-eighteenth century and is a Grade II-listed building. The view is to the east and at the time West End Lane had few houses between the Pheasant and the High Street (HHLHS). Although marred by advertisements, the external appearance has changed little in the intervening years. However, what was a country lane in 1910 is now lined with houses on either side.

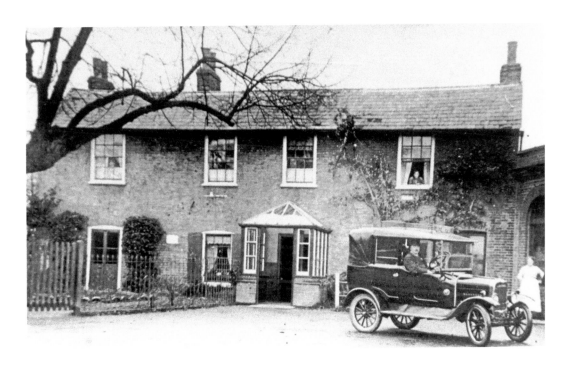

The White Hart

The White Hart dates from 1810, although there was a pub of the same name on the site before this. The licensee from 1914 to 1928 was William Dolan and his daughter Eileen is at the upstairs window. The car is a Model T Ford chassis with a modified body to carry passengers (E. Dolan). The original wing of this Grade II-listed building is still easily identified today, although there are two later extensions on the right.

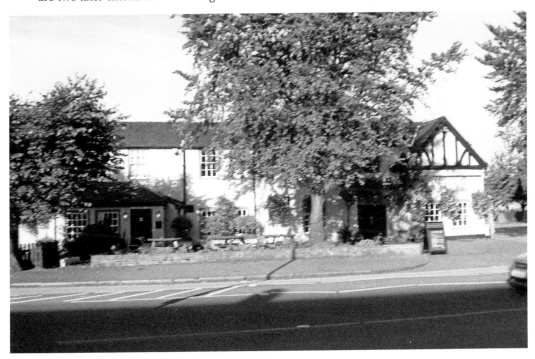

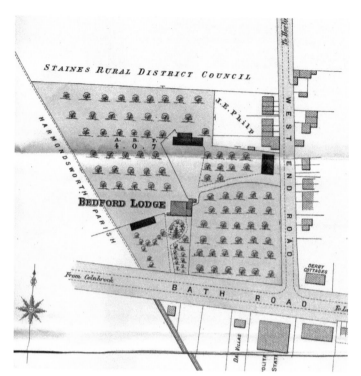

Bedford Lodge

Sale details of Bedford Lodge in 1921. Bedford Lodge was an early nineteenth-century house standing in large grounds at the junction of New Road and the Bath Road. The Radisson Edwardian Hotel was built on the site of Bedford Lodge in 1947. Its original name was the Skyways Hotel and it was the first of the many hotels that now occupy the Bath Road frontage. Since it was built the front has been completely remodelled.

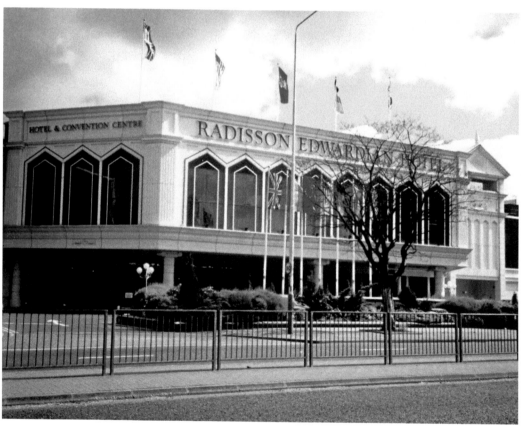

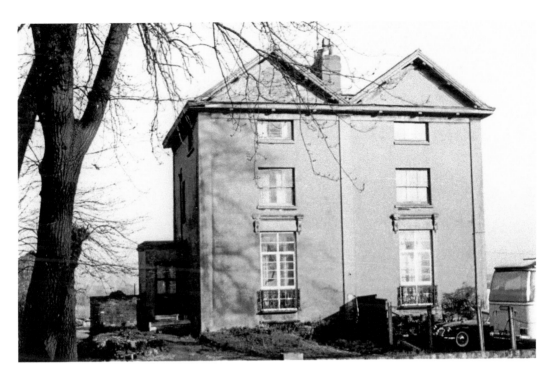

Sheraton Skyline and Marriott Hotels

This pair of large houses stood midway between New Road and Harlington Corner. They were demolished together with some adjoining cottages in 1972 and the site remained vacant for many years. The hotels now occupy the site of the houses seen in the previous photograph.

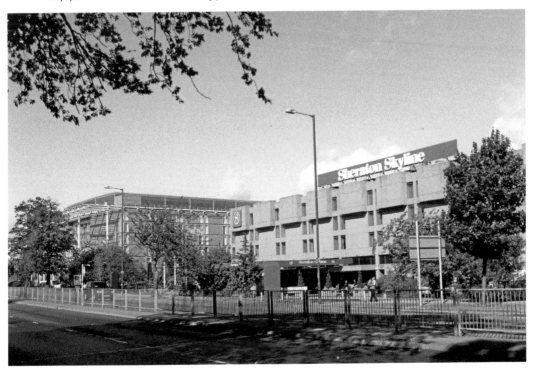

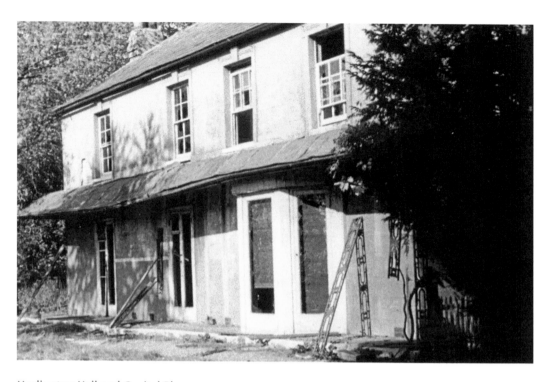

Harlington Hall and Capital Place

Harlington Hall in the course of demolition in 1961. This large house stood on the west side of Harlington Corner. Capital Place on Harlington Corner in 2004. This block of offices was built on the site of Harlington Hall in the 1970s.

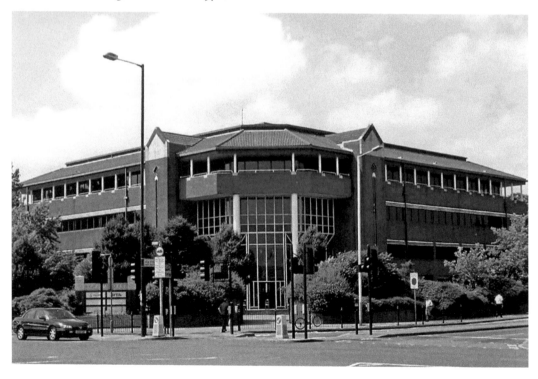

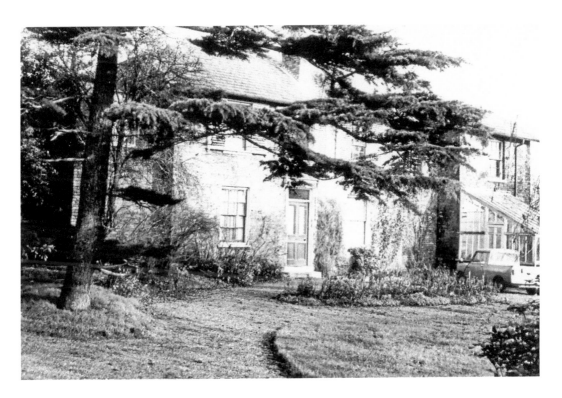

Ash Cottage and the Ibis Hotel

Ash Cottage in 1967. This mid-nineteenth-century house stood a short distance to the east of Harlington Corner. It was demolished shortly after this photograph was taken.

The Ibis Hotel (seen here in 2004) was built on the site of Ash Cottage. The tree on the left also appears in the previous photo.

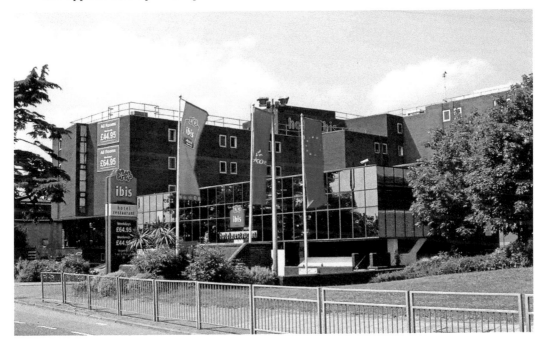

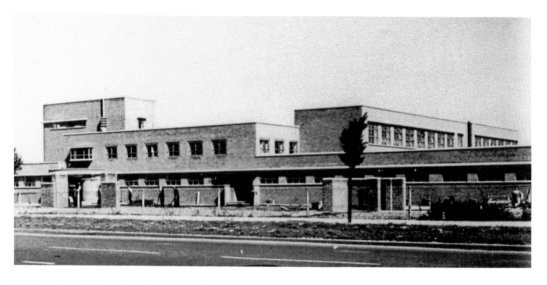

William Byrd School and Status Park

William Byrd School, Bath Road, in 1939. As a result of the rapid expansion in the population of the area in the 1930s, Middlesex County Council built a new school that was named after William Byrd, the Elizabethan composer who had lived in Harlington between 1577 and 1593. The school opened in 1939 and closed in 1974 when the children were transferred to a new school with the same name in Victoria Lane (Uxbridge Library). The image below shows Status Park, Bath Road, in 2004. After several botched attempts Hillingdon Council eventually managed to sell the site of the school which is now occupied by several office buildings.

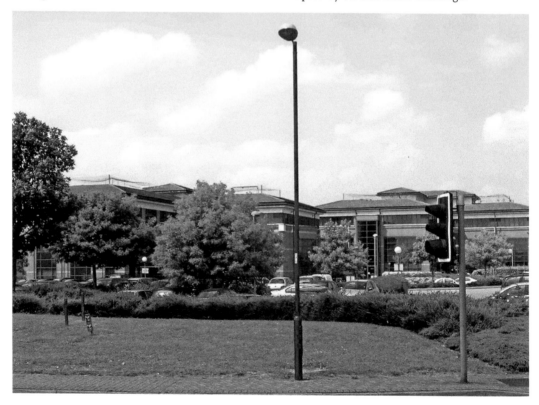

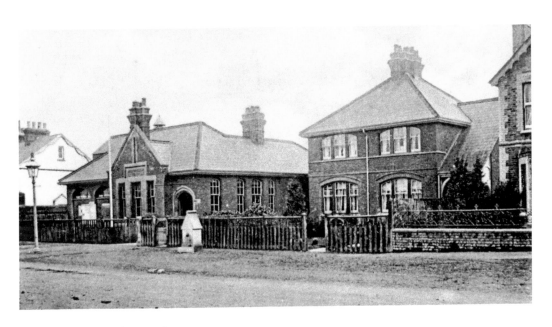

Harlington Police Station

Harlington Police Station in Bath Road in early 1900s. The police station, which opened in 1890, stood on the south side of the Bath Road opposite to the junction with New Road. To the right of the building the semi-detached pair of houses were occupied by members of the force. On the extreme right Fern Villas can just be seen and Pomona Place is on the extreme left. The station closed in 1965 and the constabulary transferred to a new station in West Drayton (HHLHS). The police station at West Drayton has since closed and Hayes Police Station on the Uxbridge Road (seen in the lower photograph) is now the only police station in the area covered by this book.

Harlington, Cranford and Harmondsworth Cottage Hospital

Harlington, Cranford and Harmondsworth Cottage Hospital, Sipson Lane, in 1930. The hospital was opened in 1884 as a joint venture of the three parish councils. In its later years it became a maternity hospital before its closure in 1974. The building was sold to the Sant Narnkari Mandal Universal Brotherhood soon after its closure but its external appearance has not been changed. The image below shows the hosipital in 1990.

Former Cottage Hospital, Sipson Lane, 1990

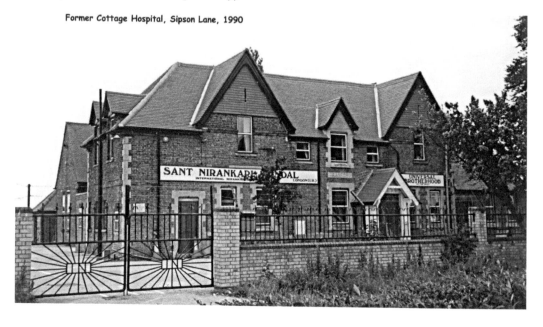

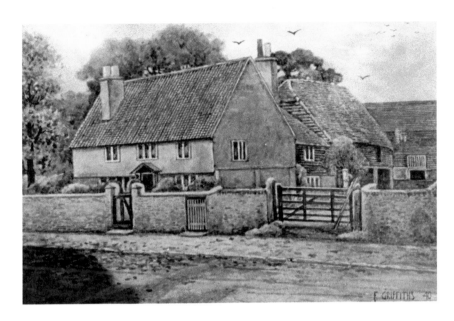

Dawley Manor Farm and Church Farm

Dawley Manor Farm, High Street, in 1935. This painting was commissioned by the owner when it was feared that the farmhouse would be destroyed by the widening of the High Street. In fact it survived until the early 1960s when it was demolished to make way for the M4 motorway. It dated from the seventeenth century and, despite its name, it had no connection with Dawley (F. Symmons). Church Farm, as its name suggests, was an eighteenth-century farmhouse that stood immediately opposite the church. It became vacant in the 1970s and became derelict. As a result it was demolished and its site has remained vacant ever since. (HHLHS)

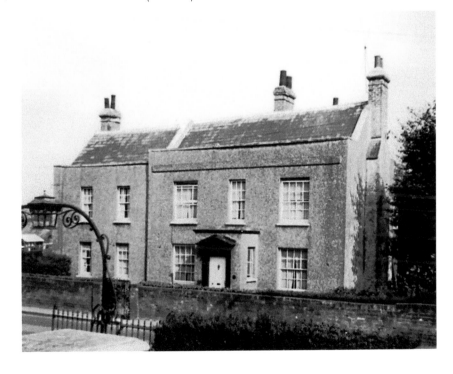

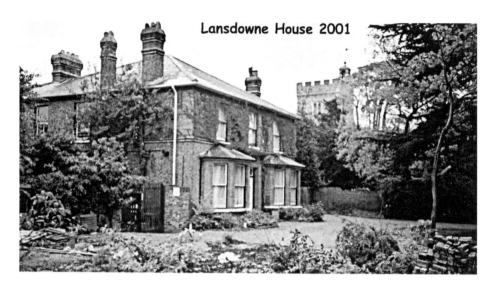

Lansdowne House 2001

Lansdowne House and Bedwell House

Lansdowne House in 2001. This house was built in the 1870s for Robert Newman, a member of a local farming family. Together with Bedwell House (*see* below) it is the last survivor of one of the many farm houses that once lined the village High Street. It gives a good indication of the prosperity of farming in the Heathrow area before it was virtually destroyed by the development of the airport. Following the death of Robert Newman in the 1930s the house became a private school, then a doctor's surgery and now a hospice.

Bedwell House (seen below in 1970) was built for Charles Newman in the 1870s on the Station Road frontage and at the time stood in splendid isolation on the edge of its adjoining farmland which is now occupied by the houses in Bedwell Gardens and Dawley Road (*see* page 61) At the time that the photo was being taken it was used as offices by the Labour Party. It is currently (2017) in use as a veterinary clinic and consequently has been re-named Petwell House.

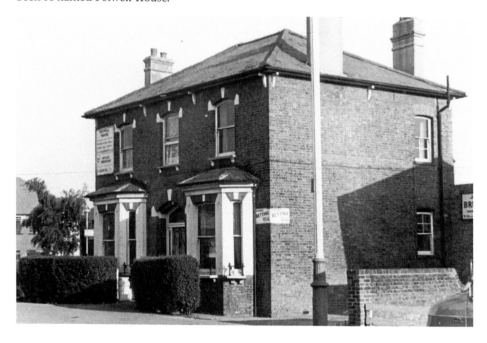

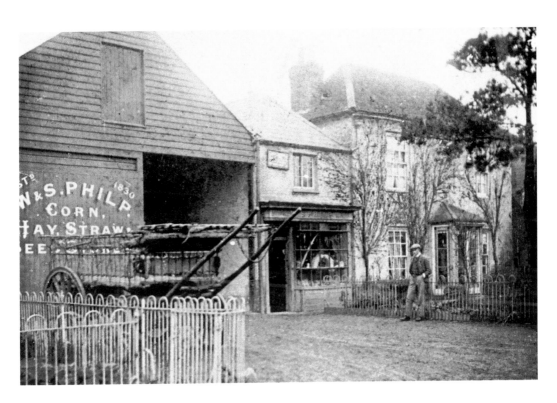

Philip's Farm and Veysey's Farm

Philp's Farm, Vine House and baker's shop, High Street, in early 1900s. Vine House was the home of William Philp of W&S Philp, who were local farmers. They also ran the baker's shop next to Vine House. (J. Allport). The site of Philp's Farm was derelict for many years until in 1977 it was bought by Hillingdon Council to build the small housing development shown here.

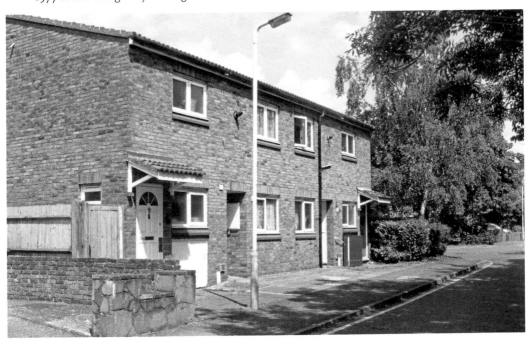

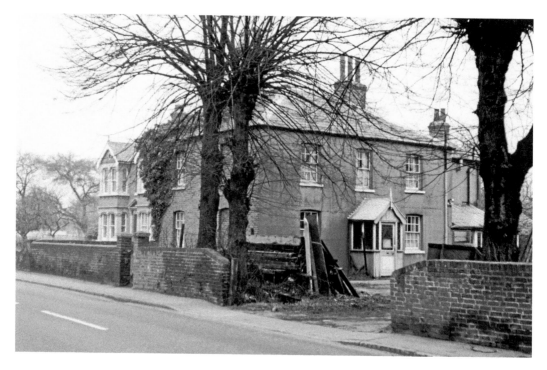

Veysey's Farm

Veysey's Farm, 1968. This mid-nineteenth-century farmhouse stood opposite to Philp's Farm but had long since ceased to be a working farm. During its later years the premises were being used as a woodyard selling second-hand timber. The house known as Bletchmore can just be seen to its left. Both were demolished in the 1980s and the houses in Bletchmore Close now occupy the site. Below, the site of Veysey's Farm and Bletchmore in 2013.

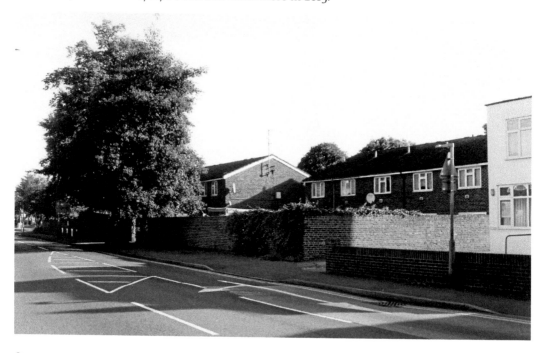

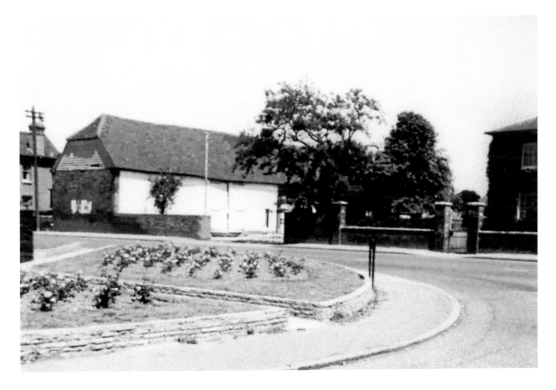

Heyward's Farm, High Street, 1958
This stood opposite to the junction of the High Street with West End Lane. Ebenezer Heyward's farm was one of the largest in the area. His farmhouse, known as The Elms, can just be seen on the extreme right of the above image. Heyward's Farm was demolished in the 1960s and the terrace of houses seen on the left below now occupy the site. The terrace on the right was built on the site of another large house known as Little Elms. (HHLHS)

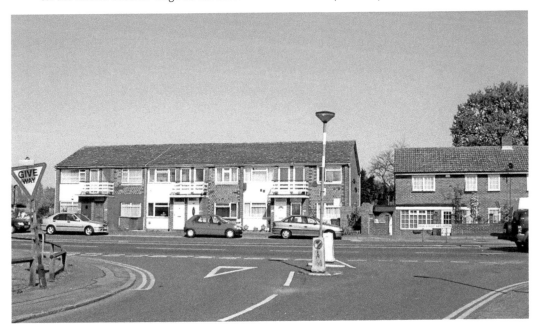

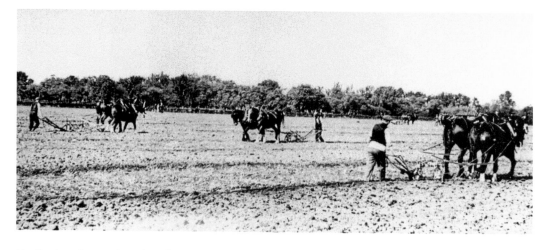

Harlington Corner (1935) and Frogsditch Farm (1969)

The Middlesex Agricultural and Growers Association held its annual ploughing match in early autumn. This particular match was the ninety-seventh and was won by Mr A Prosser, who can be seen on the right of the above image. He won it again in 1937, which was the last match to be held because of a drought in 1938 and the outbreak of war in 1939. On his grave, A. Prosser, who died in 1980, is recorded as being the last champion ploughman of Middlesex.

Frogsditch Farm was named after the stream that runs through it. In 1969 it was owned by F. W. Longhurst, who had formerly owned a farm at Heathrow before it was requisitioned in 1944. After his retirement it was bought by a gravel company, but after extraction the land was restored and has since become a sports field. The area occupied by the farm buildings was taken over for various unauthorised commercial uses completely incompatible with a Green Belt designation. (Above image courtesy of Uxbridge Library.)

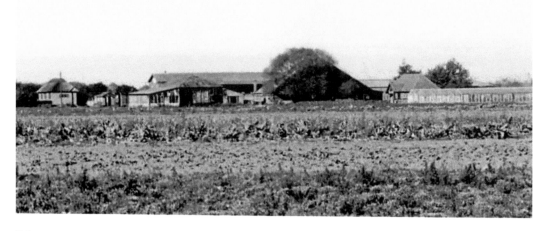

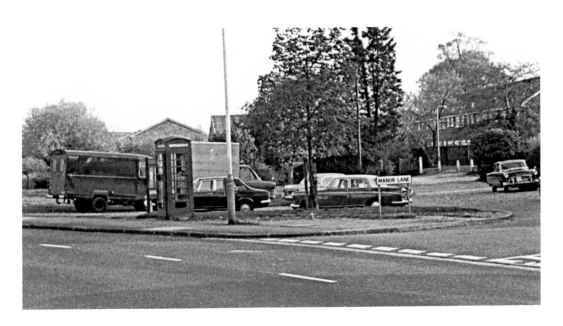

The Village Centre

The village pond had once occupied the area behind the parked vehicles. It was filled in during the 1950s because it only occasionally held water and had become a dumping ground. The area with the telephone box and lamp post had once been the site of the village lock-up and cattle pound. The photo shows that the land between the two was regularly used for parking and the pond/pound area in the centre of the village had become very rundown.

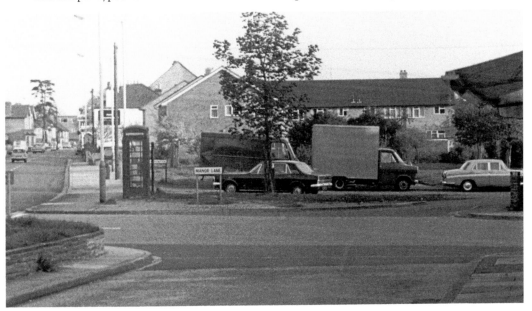

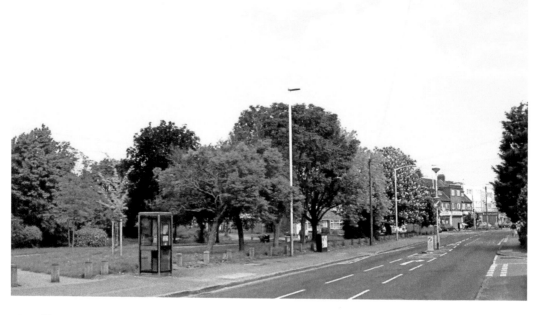

The Village Centre

In 1977 the Harlington Village Association proposed that the pond/pound area should be rehabilitated to celebrate the Queen's Silver Jubilee. The cost of the project was funded with a grant obtained from the Civic Trust, funds provided by the Association and topped-up by Hillingdon Council. The photo shows the results of the scheme, with the area now regarded as the village green to form an attractive centrepiece to the village.

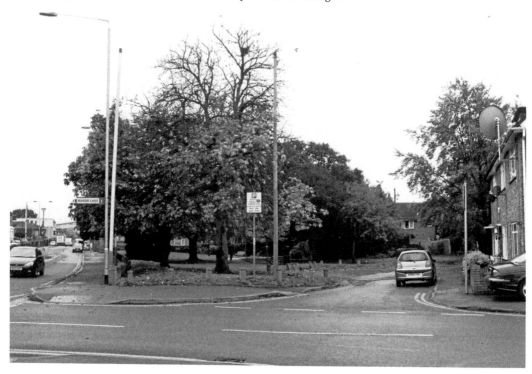

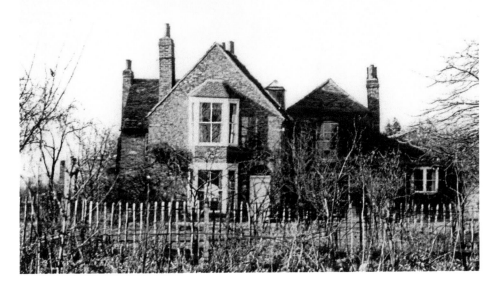

The Lilacs

This house, which dated from the sixteenth century, stood to the south-west of the pond. It was reputably the home of William Byrd, the Elizabethan composer who lived in Harlington between 1577 and 1592. It had been previously known as Overberg House and for much of the nineteenth century it had been used as a private school. The house was demolished in 1967.

The lower image, from 2015, shows the modern houses that were built on the site of the Lilacs, and the area has been linked with the Crescent in West End Lane by the footpath seen in the foreground.

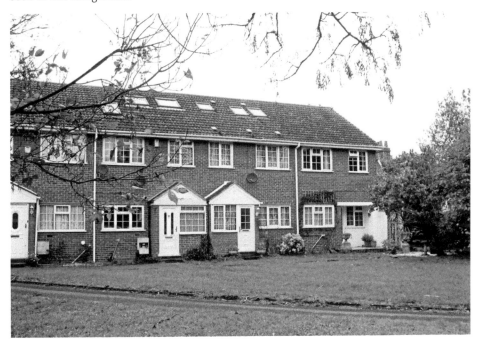

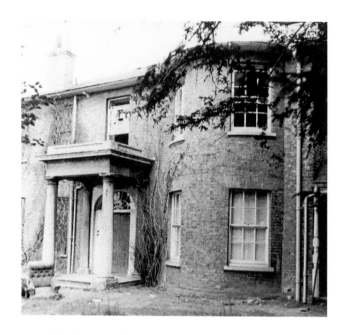

Shackle's House and Harlingtton High Street

This large house on the High Street had no other name than that of its owner. It dated from the late eighteenth century and stood opposite to the White Hart. It originally stood in large grounds that are now occupied by the houses in Richards Close and by the Locomotive Society. Despite this fact, it had been built close to the road so that what appeared to be the front of the house was in fact the back. The view above shows the actual front that was hidden away from the road. The house was demolished in the early 1960s and replaced by the houses in Pembury Court.

Charles Shackle (1875–1960) and his wife can be seen below in their 1905 model twin-cylinder 10-hp Rolls-Royce, parked outside his house in the High Street. The photograph (*c.* 1920) is obviously posed because at that time Charles Shackle was unable to drive. His chauffeur, standing next to the car, must have driven it away soon after. (Image above courtesy of HHLHS; image below courtesy of V. Shackle)

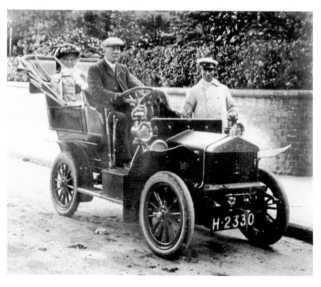

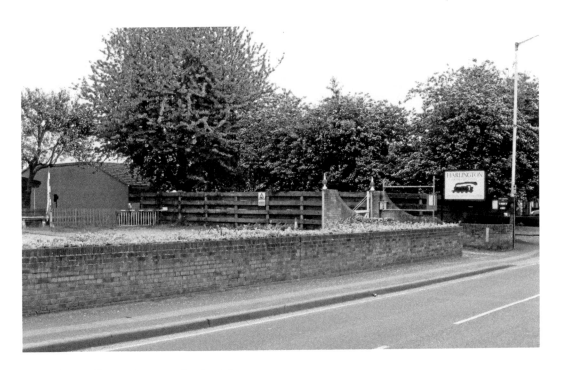

The Harlington Locomotive Society

In 1947 Charles Shackle, who had by then retired from the Great Western Railway, invited model railway enthusiasts to join him in the construction of a model railway line in an orchard to the south of his house. This led to the formation of the Harlington Locomotive Society. The lower image shows Harlington Locomotive Society in the early 1950s. The society regularly holds Open Days with rides given to children, as seen in this photograph. The building in the background is what had been the National School. (Image below courtesy of P. Tarrant)

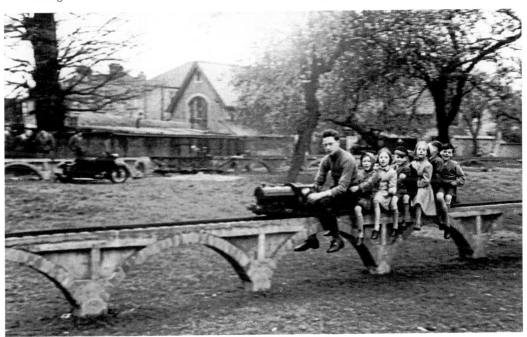

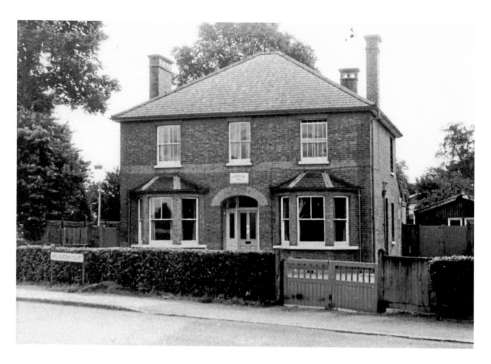

Townsend

The image above shows Shepiston Lane in 1968. At the time that this house was built, in 1910, its name was appropriate because it was at the northern extremity of the main part of Harlington village. At the time this photograph was taken, the house was still in private occupation but soon after it became a school for children with additional needs. It was then acquired by what was then the Arlington Hotel, which stood behind the house and was used as an annexe by the hotel. Townsend has since been demolished and replaced by the white building in the centre of the photograph below. The Arlington Hotel has been rebranded and is now part of the Mercure chain of hotels.

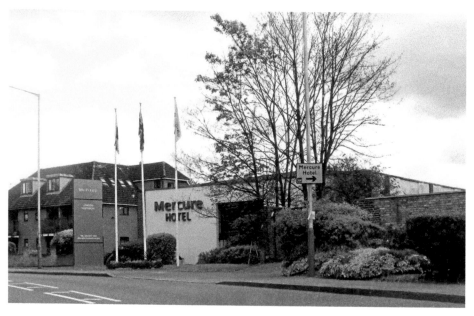

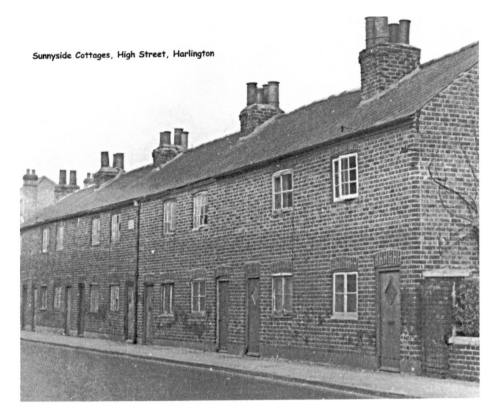

Sunnyside Cottages, High Street, Harlington

Sunnyside Cottages

This row of nine cottages dated from the early 1800s. They were known locally as the Nine Houses but had previously been known as Sapperton Row. They were demolished soon after the above photograph was taken and replaced with the buildings seen in the lower photograph. (Courtesy of HHLHS)

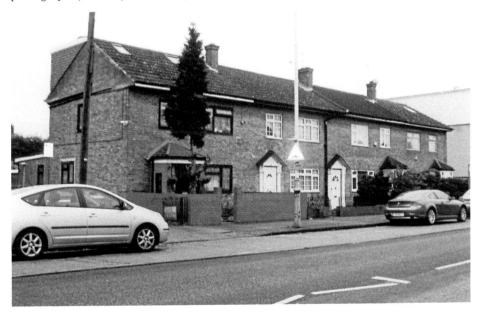

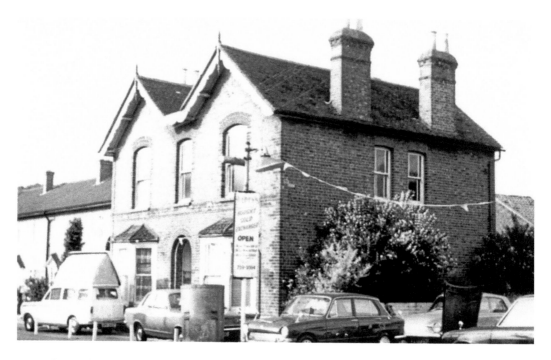

Car Sales, High Street

This large early twentieth-century house was one of the last such houses to be built in the High Street. It had long since ceased to be used as a residence and had become the premises of a car dealer. It was later demolished and its site had become an airport-related car park. Fortunately this development was short-lived and the site is now occupied by the buildings seen in the lower photograph.

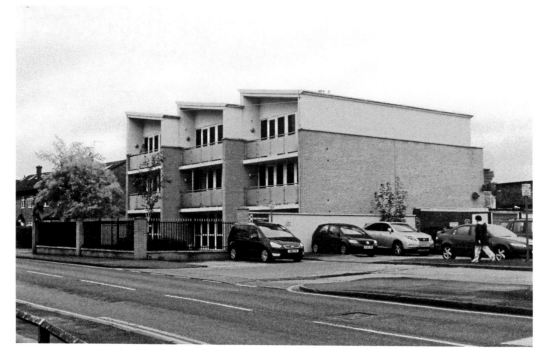

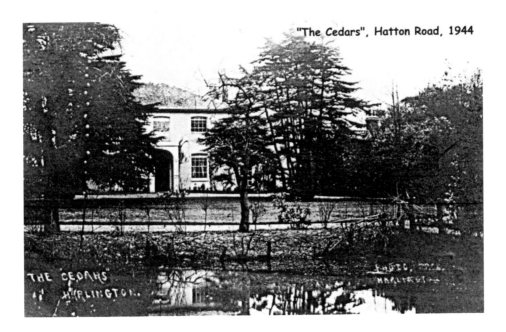

"The Cedars", Hatton Road, 1944

The Cedars and Hatton Gore

Prior to the enclosure in 1821, the segment of Harlington parish that lay south of Bath Road formed part of Harlington Common and hence none of the buildings in that part of Harlington could have predated 1821. However, several fairly large houses appeared soon after, two of which are shown here. The Cedars was at one time the home of Mary Ann Cooper (née Mitton), who was the inspiration of Charles Dickens's character Little Dorrit. As a friend of the family, Dickens was a frequent visitor to the house. In the 1930s Hatton Gore was the home of Frank Kingdom Ward (1885–1958), a famous plant collector. During the war the house was occupied by the Welsh Guards and later by the Home Guard. In 1944 all the land south of Bath Road was requisitioned to make way for Heathrow Airport and consequently all the buildings in Hatton Road were demolished. (Courtesy of HHLHS)

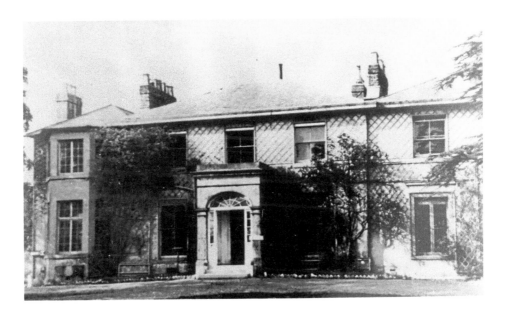

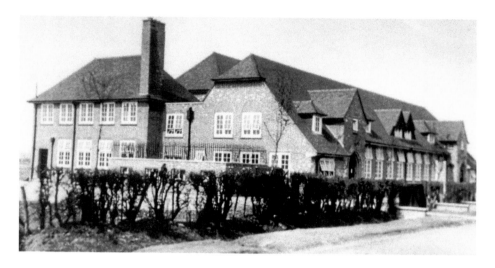

Harlington Senior School and Community School

This was opened by Middlesex County Council exclusively for pupils from the age of eleven to fourteen who had failed to meet the entry requirements of the county grammar schools and technical schools. Similar senior schools were opened throughout the county, thus instituting a system of education that the rest of the country was not to see until the passing of the 1944 Education Act. After this, the school was renamed Harlington Secondary Modern School and it continued under this name until the introduction of comprehensive education in the area. It closed in the early 1990s, when the pupils were transferred to the school in Pinkwell Lane (*see* below). The building was eventually demolished in 1995 and its site used as a car park for the adjacent airport hotel.

Harlington Community School in Pinkwell Lane was built as a replacement for the school in the upper photograph. The shed-like structure compares very unfavourably with its red-brick predecessor and shows how school architecture has been debased over the succeeding years. (Image above is courtesy of Uxbridge Library)

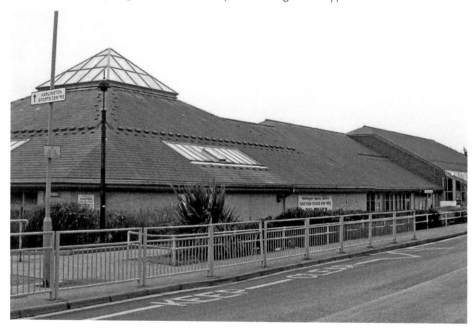